CHESTERFIELD IN 50 BUILDINGS

RICHARD BRADLEY

AMBERLEY

First published 2019

Amberley Publishing, The Hill, Stroud
Gloucestershire GL5 4EP

www.amberley-books.com

British Library Cataloguing in Publication Data.
A catalogue record for this book is available from the British Library.

ISBN 978 1 4456 9063 6 (print)
ISBN 978 1 4456 9064 3 (ebook)

Typesetting by Aura Technology and Software Services, India.
Printed in Great Britain.

Contents

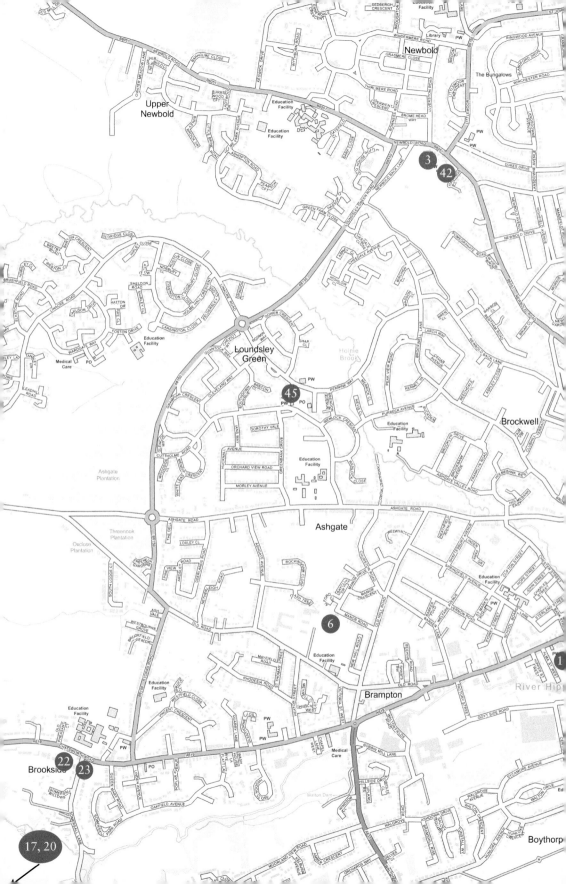

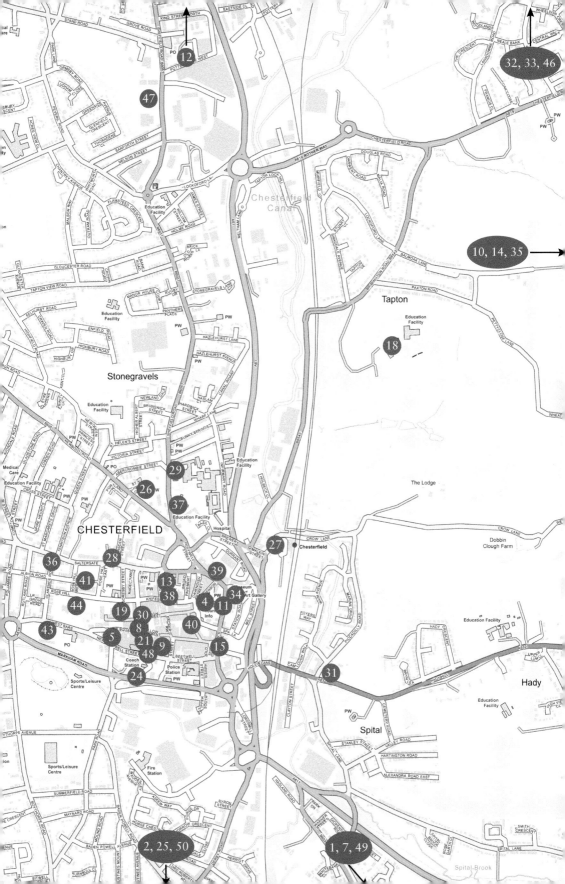

Key

Introduction

The Derbyshire town of Chesterfield is world-famous for its shoddy architecture: the Crooked Spire of the Church of St Mary and All Saints towers wonkily over the townscape, and is a visible landmark for miles around when approaching the town from the surrounding countryside. Its iconic silhouette has been embraced by the borough council for their logo and employed as branding for all manner of products manufactured in the town – from tea to pickled onions.

Whoever cares to look closer will find that its trademark kink distracts from what is actually a large, impressive and historic parish church, packed to the rafters with fascinating features. Similarly, because of the character of the town – hard-working, practical, down to earth, unshowy, taciturn – which to a large degree stems from its past (regrettably, this is something that *is* nowadays largely consigned to the past) as a major UK manufacturing base, it is easy to overlook the area's numerous fine buildings from across the ages of history. In 1990 English Heritage commissioned a town planning manual using Chesterfield as a case study. It offered guidance as to how town centres in the UK might perform the delicate balancing act of modernising and keeping pace with contemporary shopping and living needs, while at the same time retaining their historic architecture and sense of distinctive local heritage. The author helpfully observes early on that Chesterfield is not York,

Chesterfield town centre, as viewed from Tapton.

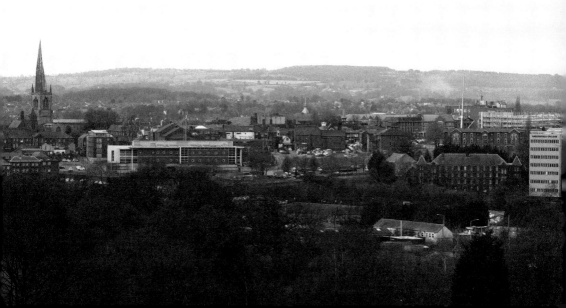

Bath or Chester, the inference being that this North East Derbyshire market town does not exert quite the same tourist pull as these iconic English cities. However, Chesterfield retains a high proportion of characteristic period buildings dating from the medieval, Georgian and Victorian eras. (Although, walking the town's streets, all is not always as it at first might seem: the several Tudorbethan buildings are largely a 1920s facsimile, and on Low Pavement a modern shopping centre has been knitted to the historic façade of a period frontage.) Meanwhile, at The Peacock the important historic interior of a medieval timber-framed building dating to around 1500 was only revealed by chance when a 1974 fire burnt away the art deco frontage that had subsequently encased the ancient property.

The historic town centre, concentrated around the focal point of the cobbled market square with its Victorian market hall and distinctive Georgian shopfronts, would look very different today had a radical 1960s town centre modernisation programme drawn up by architect J. S. Allen not been overturned at the eleventh hour, in the face of coordinated protest from individuals and heritage groups. Allen did manage to give Chesterfield a smaller scale taste of the future with his brutalist Courthouse of 1963–65, but court proceedings were subsequently relocated, and the abandoned building has slid into decay.

While its paths are less well trodden by comparison to the nearby Peak District, the North East Derbyshire countryside surrounding Chesterfield is home to some fine country houses, like the innovatively ostentatious Hardwick Hall with its famous jingle of 'more glass than wall', and nearby Sutton Scarsdale Hall, now reduced to a mere shell after its overly ambitious original owner Nicholas Leke, 4th Earl of Scarsdale, bankrupted himself by styling his home in an excessively lavish fashion in a bid to outdo other local aristocrats.

Chesterfield formerly promoted itself as 'the Centre of Industrial England', but most of the huge and functional buildings where manufacturing took place – such as the firms of Bryan Donkin, Markham & Co. and Staveley Works – are now gone, the sites redeveloped for housing or leisure usage. Large-scale housing developments built to house the industrial workforce and their families, such as at New Bolsover and Barrow Hill, remain, however.

Given that this book was written by a staunch atheist, an unexpectedly high proportion of the buildings I selected for inclusion are churches, but I do find them fascinating buildings to explore – from the ancient and mysterious carvings, which are hard for our modern eyes to decipher, of Ault Hucknall, to the frankly bizarre (yet entirely logical, once you know about the climatic conditions that led to it being constructed in the fashion it was) Church of St James the Apostle at Temple Normanton, which must rank as one of the UK's oddest places of worship.

As with my previous book, *Secret Chesterfield*, I have been a little free with my geographical interpretation of 'Chesterfield' in order to include buildings I was especially drawn to within a few miles' radius of the town centre – the rule I employed being (as for example with Bolsover or Wingerworth) if when addressing a letter to these buildings you would include Chesterfield prior to the postcode, they felt like fair game for inclusion.

The 50 Buildings

1. St John the Baptist's Church, Ault Hucknall – Eleventh Century

With its two houses, a farm and the Church of St John the Baptist, tiny Ault Hucknall, 6 miles from the centre of Chesterfield, has been claimed as the smallest village in England – if applying the rule that the presence of a church elevates a settlement from hamlet to village (not necessarily a rule a geographer would accept).

Ault Hucknall has, however, shrunken back over time, once being a larger settlement, with the eleventh-century Church of St John the Baptist remaining into

Below: The Grade I listed Church of St John the Baptist, Ault Hucknall.

Inset: Dragon carving on the tympanum.

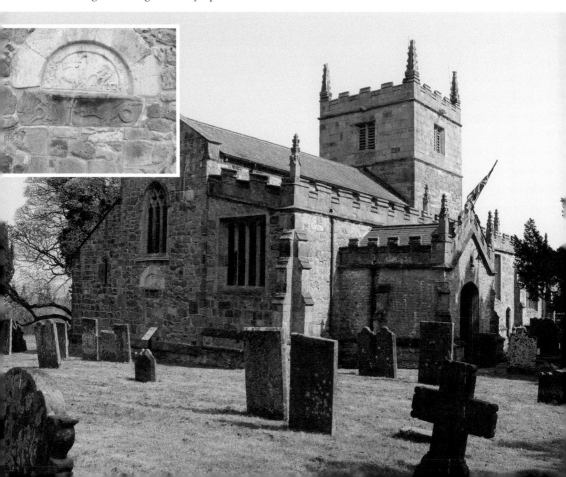

the present day as the focal point for the surrounding communities. The church contains a number of interesting features within its Norman (and later) fabric and also inside the churchyard. There are mysterious ancient carvings of stone heads and other figures on the archway between the nave and chancel; on the exterior above a blocked doorway is a tympanum and lintel displaying hard-to-decipher scenes involving a dragon.

Inside the church is the tomb of philosopher Thomas Hobbes, who was employed as a tutor to the earls of Devonshire and placed in charge of the library at Hardwick Hall. He expired at the age of ninety-one after insisting on accompanying the family on a journey from Chatsworth to Hardwick, being conveyed on a feather bed placed in a stagecoach. In the churchyard can be found the tomb dated 1690 of a cooper employed by the Devonshire family carved with the tools of his trade, as well as an ancient yew tree.

The church is Grade I listed. Given its isolated location, it is usually kept locked, but can currently be visited on Saturday afternoons from Easter until harvest, and during the village well-dressing week in July, as well as on Sundays for the weekly Holy Communion service.

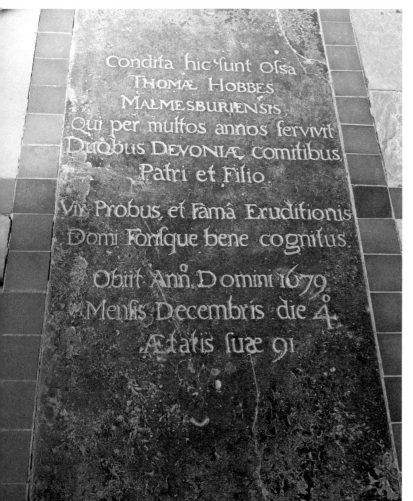

The tomb of philosopher Thomas Hobbes inside the church.

2. All Saints Church, Wingerworth – Twelfth Century/Extension of 1963–64

Stepping through the door of All Saints is a surprising experience as, once inside, the Norman arches open on to a bright, large and modern space that forms the extension of 1963–64 by the architects Naylor, Sale and Widdows, built to house the growing mid-century congregation of the expanding suburbia of Wingerworth. The 1960s were a time of bold ideas, innovation and experimentation in architecture. No attempt is made to blend the new part of the church into the existing Norman fabric, but the end results are unexpected and pleasing. It is hard to envisage an extension to a twelfth-century church being constructed in this style if it had been built at any point from the more conservative, heritage-aware 1980s onwards.

Charmingly, the church has copies for the visitor to consult of a pair of classic Ladybird children's guides from 1972, *What to Look for Inside a Church* and *What to Look for Outside a Church*, to ensure you don't get your rood screens mixed up with your reredos. And All Saints certainly has much of interest both within and without, including an exterior sundial dated 1770 on the tower, a hagioscope (or 'squint'), and a curious apparent hangover from the older nature-

The Grade I listed All Saints Church, Wingerworth.

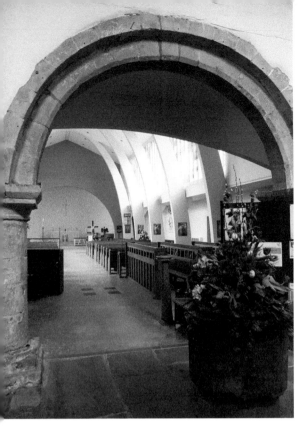

The Norman church gives way to the extension of 1963–64.

worshiping Pagan religion of the native Celtic population in the form of a Jack o' the Green (or Green Man) figure carved out of wood.

The church guide records a curious incident in the history of the building when in an unknown year the three bells in the tower 'were badly damaged by an insane person who got into the tower with a sledgehammer'. Following this episode, in 1888 the bells were recast and two more added.

The church is Grade I listed.

3. The Eyre Chapel – Thirteenth Century

Nowadays a suburb of Chesterfield, Newbold was at one point a distinct entity, recorded in the Domesday Book of 1086 where it is afforded more importance than Chesterfield, the latter being listed as one of Newbold's six berewicks (satellite estates) along with Tapton, Brampton, Old Whittington, Eckington and Boythorpe.

In the thirteenth century, the then Lord Mayor of Newbold (who also held the position of Abbot of Welbeck Abbey) built a tiny chapel here at this strategic location, being the highest point of Newbold where four ancient trackways met. In 1570, the Eyre family, who held substantial estates across Derbyshire, bought the manor of Newbold to add to their portfolio. In common with many of Derbyshire's wealthy families, the Eyres were staunchly Catholic. They used the chapel at Newbold to worship in the climate of persecution that followed the Dissolution of the Monasteries and had to pay fines during the reign of Elizabeth

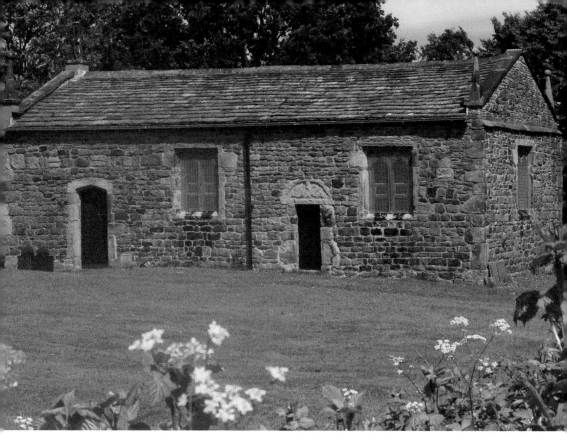

The Eyre Chapel, Newbold.

I to continue to practice their faith. This diminished their fortunes to such an extent that they ended having to sell up the manor of Newbold, while negotiating continued ownership and use of the chapel.

The religious friction rumbled on through the centuries, coming to a dramatic head in 1688 when the chapel was sacked by an angry Protestant mob who destroyed some of the tombstones. The Catholic Emancipation Act was passed in 1829, finally putting a stop to all this ecclesiastical aggro. This was not the end of the building's problems, however, as it unfortunately became a persistent magnet for vandalism in the late twentieth century (by which time it had been superseded by the building of a larger Roman Catholic church at Littlemoor) and was on the verge of falling into dereliction. Nowadays the ancient chapel finds itself a little marooned, barricaded behind green metal railings and hemmed in by housing estates, within staggering distance of the Nag's Head pub car park and sat facing the back of the Barnett Observatory (QV). Chesterfield Civic Society arranged restoration work in 1987 and a Friends group was established in 1992 to oversee the building, which can now be hired out as a village hall community space. It is still used by a diverse range of religious groups, including as a venue for services by the Orthodox Parish of St Cuthbert and meditative drumming sessions by a local Pagan group. Occasionally the building lets its hair down as an intimate venue for concerts and even, as can be seen in a Youtube video, as an impromptu recording studio by the Chesterfield-based band Blanchard.

4. The 'Crooked Spire' (Church of St Mary and All Saints) – Fourteenth Century

The Grade I listed Crooked Spire is an iconic image, symbolising Chesterfield to the world outside. I imagine some of my fellow authors in the 'In 50 Buildings' series might have agonised over which of their fifty they were going to put on the front cover. I faced no such dilemma; there was only ever going to be one contender (in fact, it is probably illegal under some obscure English law to produce a book about the buildings of Chesterfield and *not* put the Spire on the cover).

While it may provide the definitive landmark and a sense of identity for the town, the Spire is actually far from unique. Wikipedia lists 131 other known similar examples from around the world in their 'List of Twisted Spires' entry – other instances of this phenomenon in the UK include the churches at Barnstaple, Devon; Clitheroe, Lancashire; and Hadleigh, Suffolk.

There are a variety of colourful local folk tales as to how our particular spire came to be the way it is, including: on a flying visit to Chesterfield the Devil

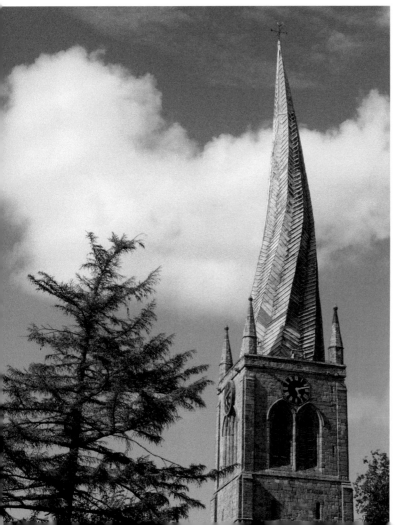

The iconic
Crooked Spire.

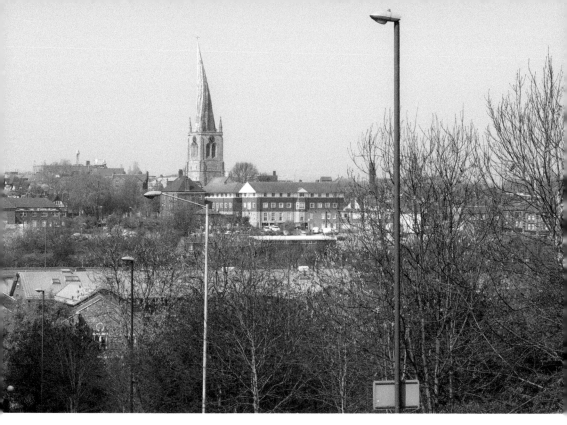

The Spire from Hady Hill.

perched atop the spire and twisted his tail around it to steady himself; a Bolsover blacksmith was shoeing the Devil and drove a nail through his foot causing him to leap in pain, just clipping the spire as he went over; and the classic canard that one day back in the dim and distant past a bride was married in the church who was still a virgin, and the spire was so surprised to hear of this unlikely event that it twisted round to have a look (the coda being that if it ever happens again, the spire will untwist itself). More academic theories put forward are that the lead placed on the timbers heated up in the sun causing the whole spire to warp out of shape, or that the shortage of skilled tradesmen in the fourteenth century following the widespread Black Death meant that the spire was completed in stages out of necessity, leaving the roof timbers exposed to the elements.

The church's spire came close to being demolished in the nineteenth century, but thankfully was restored instead. In 1961 a disastrous fire broke out caused by an electrical malfunction in the organ, which dated back to 1786 and was valued at £12,000. The Spire itself was saved by the heroic efforts of firefighters, and the archdeacon and library staff (then based across the road at the Stephenson Memorial Hall) rescued church records, processional crosses and candlesticks from the flames.

There is something curiously comforting about the crooked nature of the Crooked Spire. 'To err is human,' it seems to say to us, a reminder that sometimes in life even the best-laid plans can go awry.

Crooked Spire trinkets and paraphernalia for sale at Chesterfield's Visitor Information Centre.

5. The Peacock – 1500

Unlike the ersatz Tudorbethan timber-framed buildings that pepper Chesterfield town centre, The Peacock is the real deal. Along with its neighbours, The Peacock was slated for demolition in the mid-twentieth-century regeneration scheme. An accidental fire that broke out at the building in 1974 was a major catalyst in the subsequent ditching of this idea and the ploughing of a totally different course. At the time The Peacock was an unremarkable-looking pub with a tiled exterior. The fire revealed a clearly much older interior. For a time afterwards, accepted wisdom had it that the building had originally been constructed as a guildhall. More recent research by prolific local historian Dr Philip Riden puts forward the new theory that The Peacock was built as a private house for Revells of Carnfield Hall, near Alfreton. The first written reference to the building is in 1686, by which time it has been subdivided into tenements – originally the building was of three bays' length, but one bay has subsequently vanished. After several further changes it first opened as The Peacock public house in 1829.

The abandoning of the Allen redevelopment scheme and the alternative path taken of keeping the historic feel of the town by retaining the old shop frontages and restoring the Market Hall seemed to usher in a new-found era of confidence for Chesterfield, in which it began to find a new place for itself in a changing world, pre-empting the loss of the majority of industry conducted locally which was to all but vanish within two decades and taking steps to reinvent itself as a historic market town within reach of the Peak District countryside. The Peacock like a phoenix was reborn from the ashes of the fire in its new incarnation as a tourist information and local heritage centre, officially opened along with The Pavements by the recently married Prince of Wales and Princess Diana in 1981. Operations were moved to a new purpose-built octagonal premises next to the Crooked Spire in 2002, and at the time of writing The Peacocks is now Peacocks Coffee Lounge, a popular town centre café who in their change of use have retained the historic feel of the building.

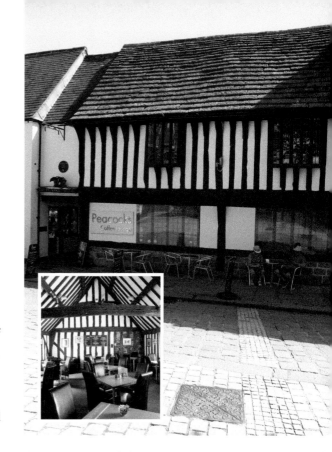

Right: The Peacock (now Peacocks Coffee Lounge), an ancient timber-framed building.

Inset: Inside The Peacock, showing the timber beams upstairs.

Below: The Peacock Inn pictured in the early 1970s prior to the fire that revealed its inner treasures. (Photo by Christine Merrick, reproduced by kind permission of photographer)

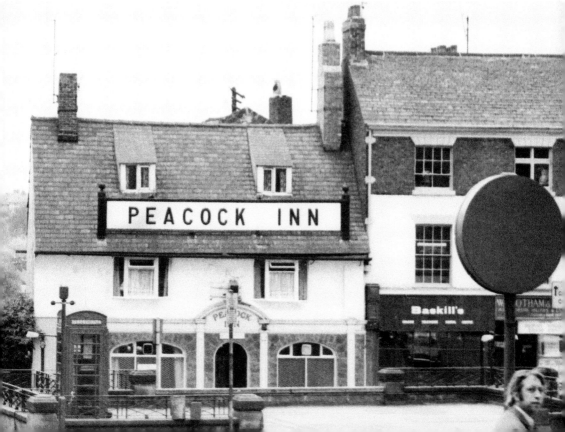

6. Brampton Manor/Brampton Manor Barn – 1585–99

Brampton is now a suburb that bustles with houses, factories, independent shops and pubs, but it was once a separate village (one of the berewicks of Newbold – see 3. The Eyre Chapel). Over time as the town of Chesterfield has expanded, Bramton has been subsumed.

Brampton Manor is thought to have been constructed by two brothers, Robert and John Watkinson, between 1585 and 1599 when Brampton was still a secluded backwater. It remained a private residence up until the mid-1960s, when it was converted into a Gentleman's Dining and Gaming Club. This incarnation was short-lived and in 1970 it became a squash club. After a period of decline, in 2005 the manor was revived as a multipurpose business offering locals a country club, pub, restaurant, gym, wedding venue, conference centre, spa and crèche.

Tucked away behind the manor is an ancient cruck barn, which a Historic England assessment describes as being 'considered a rare survival for the area'. It is a Grade II listed building, a Scheduled Ancient Monument and has been on the Heritage at Risk Register since 2002 in view of its slow decay, heightened by damp and water ingress. Analysis of tree rings from samples of timber taken from the barn estimates the trees used in its construction to have been felled around 1581–1606, with building work taking place soon after.

Brampton Manor of 1585–99.

Brampton Manor Barn, a Scheduled Ancient Monument and on the Heritage At Risk Register.

7. Hardwick Hall – 1590–97

One of England's finest stately homes, built by the ambitious Bess of Hardwick, whom the uncharitable might term a 'gold-digger'. After a series of advantageous marriages, the indefatigable Bess rose to become the second richest woman in England after Elizabeth I.

Having separated from her fourth husband, George Talbot, Earl of Shrewsbury, Bess had returned to live in her old Derbyshire family home, now known as Hardwick Old Hall. She began work on her showpiece new property close by to the Old Hall in 1590. Everything about the house was ambitious, ostentatious

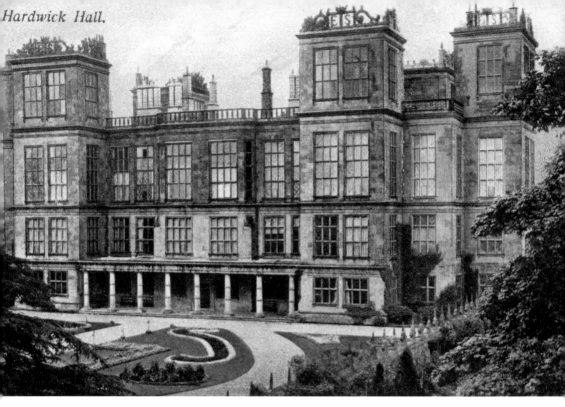

Hardwick Hall.

'...more glass than wall': Hardwick Hall pictured on an old postcard.

and innovative. For starters, it was one of the first houses in the country 'designed' by the newly developing concept of an 'architect', namely Robert Smythson (1535–1614), who trained as a master stonemason, although Bess herself was heavily involved in the building process, stamping her brand heavily on the finished article, with her initials ('ES' – Elizabeth Shrewsbury) crowning the building.

Unsurprisingly, this architectural gem is Grade I listed, and open to the public under the auspices of the National Trust, who are currently undertaking a large-scale programme of restoration and fundraising to conserve the hall.

8. The Royal Oak – Sixteenth Century

Chesterfield's narrow Shambles area gives us a flavour of what the town would have been like in medieval times, with the Royal Oak inn as its centrepiece. A painted shield on the exterior wall informs passers-by that the building is 'the oldest inn in Chesterfield & one of the oldest in England', being built in the twelfth century – though architectural historians beg to differ, dating it to the sixteenth century. The plaque also claims it as a rest house for the Knights Templar, who held land nearby at Temple Normanton.

In truth, the establishment that we see today is a bit of a Frankenstein creation, the inn originating in the lower bar, which is of a later construction date. The sixteenth-century timbered part of the pub known as the top bar was probably originally a butcher's shop – there was a high concentration of this kind of

Above left: The sixteenth-century top bar of The Royal Oak.

Above right: Inside the characterful top bar of The Royal Oak.

business in the Shambles area, the blood of the slaughtered animals draining down the sloping flagged street and into the River Hipper below. At some point in the nineteenth century the buildings were conjoined.

By the 1960s, the Shambles was living up to its name. A report prepared by Chesterfield Civic Society in 1969 against the backdrop of the town centre modernisation scheme noted, 'The general atmosphere within The Shambles is one of neglect with deposits of rubbish in odd corners, some rather smelly dustbins in some of the alleys and some dilapidated buildings', but overall thought 'It represents a piece of "Old Chesterfield" and in parts presents a picturesque appearance particularly around the old public house – The Royal Oak. The area, even in its present neglected form, has a distinctive character and interest which could perhaps be likened to the "Brighton Lanes" the "Staithes" of Hull or with a stretch of the imagination to the "Shambles of York".' The area had been earmarked for prettifying and modernising even earlier than the swinging '60s, however, with Pendleton and Jacques remarking in 1903 of the Shambles: 'There have been many proposals to sweep the cluster of quaint habitations and business places away; but they have come to naught, so far, though the scheme of street improvements may ultimately rob them of their medieval look.'

The Grade II* listing status awarded in 1971 should hopefully safeguard the building's future. The characterful old pub is fondly thought of by townspeople: there was much dismay expressed by locals when the hostelry temporarily

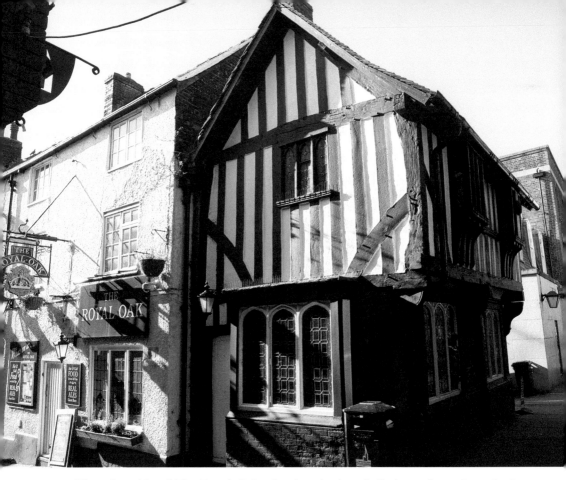

The other side of The Royal Oak, showing the later-built lower bar where the inn originated.

shut its doors in 2015, with one *Derbyshire Times* reader hoping it wouldn't subsequently end up being turned into a ye olde supermarket, and another (clearly the owner of a vivid imagination) dreaming up an ambitious rescue package for a medieval-themed bar involving open fires, lanterns, 'medieval folk bands, traditional ales, meads, and homebrew, wines in goblets. Also beer served by proper bar wenches'. Thankfully the pub subsequently reopened for trade (minus the mead and wenches).

9. Yorkshire Building Society (former Falcon Inn) – late Sixteenth Century

Dated to the late sixteenth century, the Falcon Inn provides a distinctive element of the townscape thanks to its prominent jetty – a projecting upper floor that juts out into the street further than the ground-storey level and is supported on pillars. At the time of the building's construction jetties were beginning to be phased out owing to improvements in building technology. Pevsner felt the feature 'more characteristic of Devon, e.g. Totnes, than of Derbyshire'.

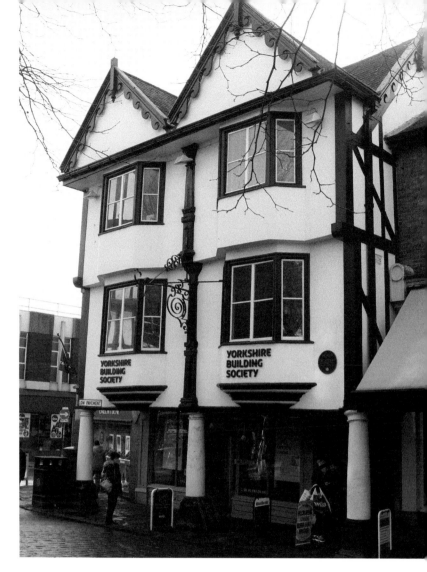

The Yorkshire Building Society, former sixteenth-century Falcon Inn.

The projecting jetty of The Falcon Inn.

In a begrudging acknowledgement of their heritage value, in the 1960s the building (then the premises of Boden's fondly remembered fish and chip restaurant) along with the previous featured building, The Royal Oak, were the two structures out of the whole of the Market Place, Shambles and Low Pavement area, which were deemed worthy of saving in the controversial Allen redevelopment plan that aimed to brutally modernise the town centre of Chesterfield. Under the plan the two buildings were to have been dismantled piece by piece, placed on rollers, removed and reassembled in some unspecified location across town, but thankfully this folly never came to pass.

10. Bolsover Castle – *c.* 1621

A castle was first built on this strategic hilltop site in the town of Bolsover in the twelfth century, but from the late thirteenth century this original castle fell into a state of disrepair. The castle that we see today was built for Sir Charles Cavendish to a design by Robert Smythson, although both died (respectively, in 1614 and

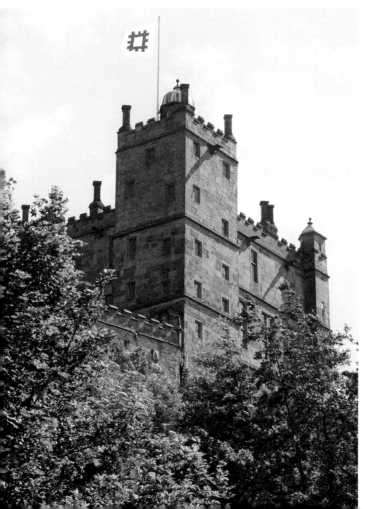

The 'Little Castle' of Bolsover Castle, built for high living rather than defence.

1617) before seeing the completion of the so-called 'Little Castle' around 1621, with operations continuing under the supervision of Charles' sons, William and John. The limestone and ashlar used in its construction came from local quarries at Bolsover, Bolsover Moor and Shuttlewood (the town lies on the Magnesian Limestone Ridge).

While resembling to a large degree the keep of a medieval castle and exuding a somewhat brooding appearance from its hilltop location when viewed below from New Bolsover (QV), Bolsover Castle Mark II was designed for luxurious living rather than for defence purposes, although not long into its life it unwittingly found itself in the midst of a conflict. The middle years of the seventeenth century were turbulent times for England, and the Civil War intervened in the progress of the building work when the castle was seized by Parliamentarian forces who slighted it (my mum who grew up nearby at Hillstown informs me of an apocryphal local folk legend that the name of the town stems from Oliver Cromwell having shot cannon 'Balls over' the castle during this period of its history).

An interior highlight of the castle is the beautiful painted ceiling in the Star Chamber. Also in the Star Chamber can be found some apotropaic marks, or 'witch marks', etched on the fireplace, a common superstitious practice in buildings of the period that was carried out to deter evil presences from entering the property. Clearly in Bolsover's case they don't work, as the building is reputedly haunted by several ghosts and was voted in 2017 the spookiest site under their care by English Heritage staff. The panoply of resident phantoms and unexplained phenomena include a grey lady, orbs of light, slamming doors, muffled footsteps, screaming, people being pushed by unseen forces, the horrific vision of a lady shoving a baby into an oven, ghostly knights and soldiers, and a little boy holding visitors' hands.

Open to the public and playing host to regular themed events throughout the year, it is one of English Heritage's flagship properties in the area, Grade I listed and a Scheduled Ancient Monument.

11. 'Heathcote's House', No. 2 St Mary's Gate – early Seventeenth Century

A neighbour of the Stephenson Memorial Hall and in the shadow of the Crooked Spire, a date stone of 1898 above the doorway of this house is misleading – the building is likely to date to the early seventeenth century. The site of the house (previously the location of an earlier dwelling belonging to the Bishop of Lincoln) was acquired by the Heathcote family of successful entrepreneurs in 1614 and is thought to have been constructed at some point over the next twenty years. The family had interests in farming and a butcher's business and substantially increased their fortunes through investing in the local lead mining industry.

Sir Gilbert Heathcote (born 1652), whose childhood home was here, was to leave Chesterfield and make substantial progress in the world, attending Christ's College in Cambridge before establishing a successful wine merchant's business in London. This was the beginning of a remarkable career trajectory that

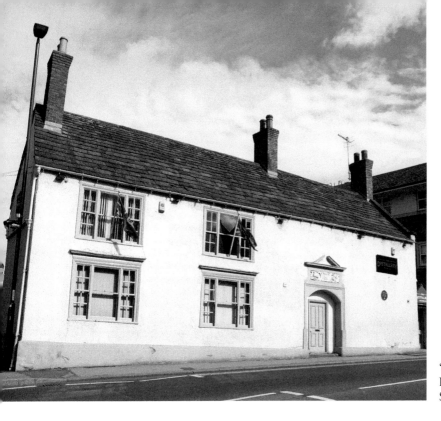

'Heathcote's House' (No. 2 St Mary's Gate).

encompassed involvement with the East India Company; becoming one of the first directors of the Bank of England, progressing to becoming its governor in 1709–11 and again in 1723–25; serving as a Whig Member of Parliament for over thirty years; and being made Sheriff of London in 1704 and Lord Mayor of London in 1711. In spite of his successes in life, he was not a popular character with the general public: despite his substantial earnings he had a reputation for parsimony, leading to him being mocked in thinly veiled form by the popular essayist Alexander Pope. This characterisation is perhaps a little unfair given that, although there appears to be no record of him returning to the town of his birth having settled in the capital, he established a local charity with £400 to go towards helping assist poor boys of Chesterfield secure apprenticeships or set up in trade. At his death in 1733 his assets totalled £700,000, leading to him being referred to by the oxymoronic title of 'the richest commoner in Great Britain'.

Sir Gilbert's brother Caleb emigrated to America, settling in the New York area where he brought a dash of north-east Derbyshire to the USA, buying up land that he named Scarsdale (Derbyshire was previously split into six administrative areas called 'hundreds' in addition to the parish of Derby, with Chesterfield and surrounding towns and villages being contained within the hundred of Scarsdale). Caleb became the Mayor of New York in 1711 – the same year that his brother was made Lord Mayor across the pond.

By the early twentieth century, this historic house had fallen out of residential use, being used as a warehouse for the business of fruit wholesaler Sir Earnest Shentall (Mayor of Chesterfield 1913–19). Green bananas sent from tropical

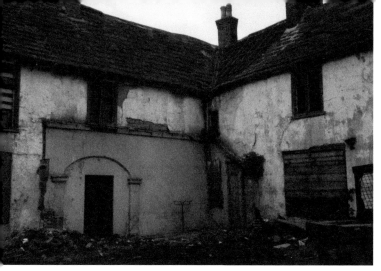

Above left: Rear of the building during twentieth-century renovation work. (Photographer unknown; reproduced with kind permission of Chesterfield & District Local History Society)

Above right: Carved doorway on Heathcote's House – don't be fooled by the date!

climes were hung to ripen in one of the rooms, and it is said that occasionally displaced snakes and tarantulas emerged from within the bunches! Afterwards, a nod to the building's go-getting former owners was provided when it became Heathcote's Restaurant. At the time of writing it forms the premises of The Distillery, a bar specialising in spirits from around the world. The building is Grade II* listed and retains its stone slate roof.

12. Revolution House – Seventeenth Century

Small and unassuming, located where the housing, shops and factories of Whittington Moor give way to the biscuit-tin charms of Old Whittington, the so-called Revolution House would be a worthy contender for *Chesterfield in 50 Buildings* in its own right, having managed to (more or less) survive four centuries of Chesterfield expanding from the town centre out into the suburbs. The building has a significance far beyond being a quaint survival of an earlier age, however, as within these humble walls events were to play out that were to change the course of history of the British Isles.

Back in the seventeenth century, Whittington Moor was indeed a moor, and Revolution House was a backwater inn going by the name of the Cock and Pynot ('pynot' being a local dialect folk name for a magpie – the two birds prop up the shield that forms Chesterfield's civic coat of arms). It was at this unassuming spot that three noblemen – Chatsworth's Earl of Devonshire, the Earl of Danby and John D'Arcy – met to plot their part in the overthrow of the Catholic James II, who had a shaky grip on the English throne. The room in which the three men formulated their plan became known afterwards as the 'Plotting Parlour'. The outcome was to go down in the history books as the Glorious Revolution

The unassuming birthplace of a Revolution.

of 1688 when the throne passed to James' Protestant daughter Mary and her Dutch husband William of Orange who landed in the UK at Torbay, with James subsequently fleeing to France. In the ultimate case of there being 'one rule for one, and one for the rest of us', if you or I were involved in deposing a monarch, this act would almost certainly culminate in a conviction for treason and being sent to the Tower; whereas the earl, for his part in the plot, received a titular upgrade to become the Duke of Devonshire, which his descendants remain to this day.

After these dramatic events the inn was converted to a cottage, with a new inn, which took on the more standardised name Cock & Magpie, built behind it in 1790; it is still in business today.

In 1788 there were large-scale centenary celebrations in Chesterfield with a grand procession, speeches and much feasting. A public subscription was established to raise money to construct a monumental column on the site of the Revolution House, with an architect from York being engaged to scope out the site. The building we see today was once considerably longer, but somewhat ironically around three-fifths of the building, including the Plotting Parlour, ended up being demolished to make way for this column. However, with the outbreak of the French Revolution the year after the centenary, the idea was subsequently abandoned and the money raised instead donated to the Derby Infirmary.

What remains of Revolution House is Grade II* listed and nowadays under the care of Chesterfield Museum. It is open to the public at weekends throughout the summer and on bank holidays, as well as over the Christmas period when it is evocatively dressed with seventeenth-century-style evergreen decorations.

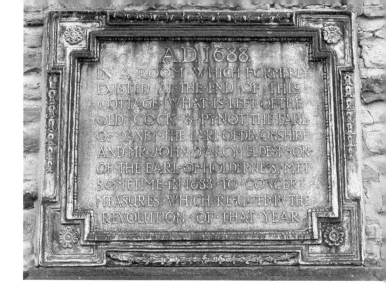

Plaque on the side of the house explaining its history.

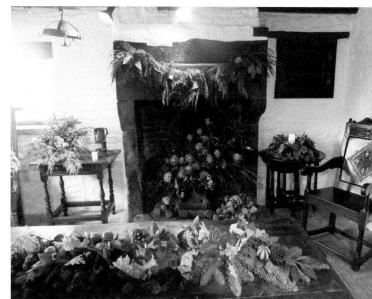

Interior of Revolution House dressed in seventeenth-century style for Christmas.

13. Elder Yard Chapel – 1694

This building was born of the religious friction that permeated English life in the seventeenth century. The congregation was founded in 1662 by Reverend John Billingsley, formerly vicar of Chesterfield parish, who was ejected from the parish church owing to his Nonconformist leanings along with his curate James Ford. They continued to lead services in secret, which were frequently broken up by constables and the militia.

In the wake of this persecution, Chesterfield, a town of independent spirit that never quite likes being told what to do, developed a strong Nonconformist presence. Following the Glorious Revolution of 1688, the Toleration Act was

Elder Yard Chapel.

passed, decriminalising Nonconformity. When first built in the 1690s, Elder Yard was used by Presbyterians and Congregationalists, but the Congregationalists moved to a new Meeting House in 1772 and the remaining congregation at Elder Yard gradually became Unitarian, which they remain to this day.

It is Derbyshire's oldest Nonconformist meeting house still in use, and Grade II listed. Set back at a stage removed from the hustle and bustle of a busy town centre shopping street in its little garden behind railings opposite the former Co-op department store (shortly to become a hotel), it exudes a sense of history, carrying on come what may.

14. Sutton Scarsdale Hall – 1724–29

What we see nowadays is a forlorn shell of a building, but this clearly once grand house was built in 1724–29 for Nicholas Leke, 4th Earl of Scarsdale, to a design by Francis Smith of Warwick. The hall is the fourth or fifth building on the site and Smith's design incorporated elements of an earlier house. The architect's brief was to build a grand residence that would rival other local stately homes, like Chatsworth; indeed, when viewed from the east frontage the ruins have a feel of a post-apocalyptic

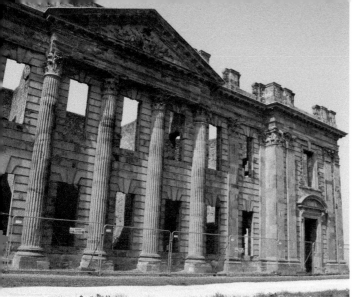

Above left: The shell of the once-grand Sutton Scarsdale Hall.

Above right: Imprisoned eighteenth-century Italian stucco work.

Chatsworth. Leke lavished particular attention (and money) on the interior of the house, securing the services of the finest craftspeople money could procure, including the Italians Francesco Vassalli and Giuseppe and Adalbertus Artari. There were fireplaces carved out of marble and Blue John and a carved mahogany staircase.

In 1824, Richard Arkwright Jr, son of inventor and entrepreneur Sir Richard Arkwright who had established his cotton factory system at Cromford, bought Sutton Scarsdale. The last of the Arkwrights to own the hall, William Arkwright, experienced a serious accident while out hunting, which left him partially paralysed and may have been a factor in his subsequent marriage producing no heirs to leave the hall to. It has been speculated by literary gossips that William could have provided the model for the impotent, wheelchair-bound aristocrat Clifford Chatterley in D. H. Lawrence's infamous novel *Lady Chatterley's Lover*. In keeping with Lawrence's modus operandi, the novel contained fictionalised elements of real life – locations as well as people. The book, which is based around the (fictional) country seat of Wragby Hall, is clearly placed by Lawrence in the locus of north-east Derbyshire with Chesterfield, Sheffield, Renishaw, Barlborough, Staveley, Bolsover and Hardwick Hall (renamed 'Chadwick Hall') all featured.

In 1919, William auctioned the hall and estate. It was bought by a consortium of businessmen who asset-stripped it, going so far as removing the lead roof. Common belief has it that after the sale the interiors of Sutton Scarsdale supposedly went on globetrotting journeys. The story goes that panelling from the mansion was bought by American newspaper magnate William Randolph Hearst for his own home, before he sold it on to Paramount Studios who used it as backdrop in a set for the 1940s Hollywood period drama film *Kitty*. The interiors of another room are meant to have been sold to the Philadelphia Museum of Art and put on display there. While researching *Secret Chesterfield* in 2017 I was in contact with the museum's Donna Corbin, who explained this had not proved to quite be the

case. Donna informed me that their panelling had been purchased in the 1920s from the notorious London dealer Charles Roberson of Knightsbridge, and that she and architectural historian Dr Andor Gomme had together determined that only a small fraction of their panelling is in fact likely to have originated from Sutton Scarsdale. 'This was not a unique situation,' Dona told me, 'many of the historic interiors that made their way into American museums were not what they were said to be.' The Huntington Library in Pasadena, California acquired the panelling that had been used by Paramount Studios but believe themselves to have been similarly swizzed. While I hate to pour cold water on a good story, this all rather begs the question: where *did* Sutton Scarsdale's panelling actually end up?

Devoid of a roof and stripped of its innards, the building began to decay alarmingly. Sir Osbert Sitwell of nearby Renishaw Hall (who, as it happens, is another real life figure proposed as Lawrence's model for Clifford Chatterley) bought the hall in 1946 after becoming aware that the remaining shell was to be sold off for the exterior stonework to be dismantled and reused by builders. Sitwell desired the exterior of the hall to be preserved as a permanent memorial to the folly of the human race in allowing such a fine example of an English country house to descend into such a state. In 1970 Osbert's descendants persuaded the Department of the Environment to take on the custodianship of the ruins. Until recently it was possible to wander round inside the skeleton of the building, but at the time of writing they are fenced off as current owners English Heritage are undertaking a programme of works in order to stabilise the building's remains and restore and protect the remaining fragments of the interior stucco work.

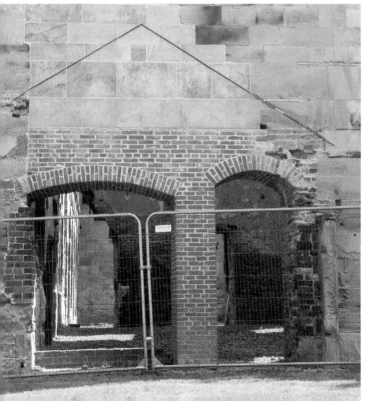

Recent repairs to shore up the fabric of Sutton Scarsdale.

15. No. 42 St Mary's Gate – Mid-eighteenth Century

Wiltshire-born Celia Fiennes (1662–1741), the daughter of a politician, was a pioneering travel writer who journeyed the country on horseback noting down what she observed on her travels, leaving us with a vivid picture of English life around the turn of the seventeenth and eighteenth centuries. In an oft-quoted remark that makes its way into most local history books covering the area (and this one is no exception), Celia praised the ale brewed in Chesterfield, observing, 'In this town is the best ale in the kingdom generally esteem'd.' By the mid-nineteenth century, three major breweries were operating in Chesterfield under the brand names Brampton, Chesterfield and Scarsdale. As the blue plaque on the exterior records, No. 42 St Mary's Gate formed the offices of the Scarsdale Brewery, with the brewhouse itself formerly located to the rear. The brewery was sold to the Whitbreads chain in 1958, who closed it down the following year. When originally built, No. 42 St Mary's Gate had been a substantial private house, in the hands of Revd Thomas Astley who bought it in 1814, and passing to his family after his death. In 1829, the house was put up for auction complete with coach house, stable, cow house, garden house, together with almost an acre and a half of land in the form of a garden and croft. The house was bought in 1833 for £900 by a George Mugliston; by his death in January 1844 the brewery had been constructed to the rear, on the site of the croft. The premises subsequently

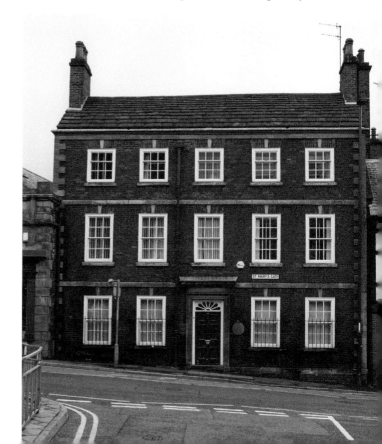

The characteristically
Georgian No. 42
St Mary's Gate.

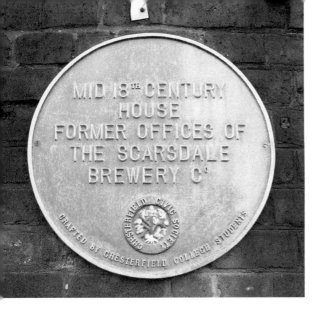

Blue plaque recording the building's former use as headquarters of the Scarsdale Brewery.

passed through various hands with the Scarsdale Brewery Company established here in 1865. By 1866, the brewery had diversified in their operations with No. 42 St Mary's Gate becoming reborn as the Scarsdale Hotel, advertising itself as a high-class accommodation with smoking and billiard lounges and pleasant gardens located a few minutes' walk from Chesterfield railway station.

Following the closure of the brewery, the building has been occupied by the NHS for several years, providing a base for mental health services. A Grade II* listed building, it retains some of its original interior panelling and from the exterior, in spite of the various changes of use over time, it has not lost its characteristic eighteenth-century charm.

16. Cannon Mill – Mid-eighteenth Century

Chesterfield once styled itself as the 'Centre of Industrial England', but regrettably the majority of this industry has now departed. Much of the industrial activity was concentrated in the New Brampton area to the west of the town centre, which is where we find Cannon Mill, Chesterfield's oldest surviving industrial building. It is known to have been in existence by 1775 (as with Heathcote's House, this is another building with a confusing date stone bearing a later date – in Cannon Mill's case, 1816). At this point in time the mill drove the machinery for the Griffin Foundry.

The foundry was a powerhouse for Britain's Industrial Revolution, manufacturing Newcomen steam engines and pumping machinery, used locally in the great lead mines at Mill Close Mine, South Darley and Yatestoop Mine, Winster. A Newcomen engine made at Cannon Mill used in the coal fields at Oakerthorpe Colliery from 1791 before subsequently being transferred to Pentrich Colliery in 1841 is now after a long working life of 127 years on display at the Science Museum in London (Object Number 1920-124/1), the largest preserved example of its kind in the country.

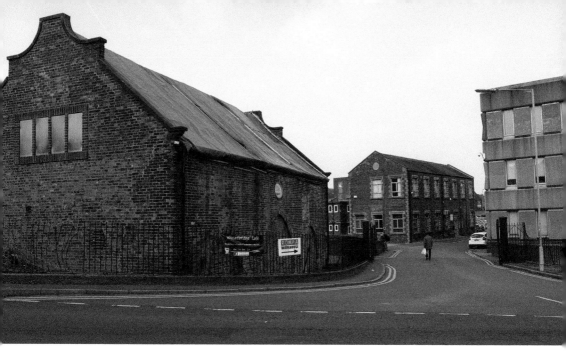

Cannon Mill (left) with Robinson's Works behind.

The turn of the eighteenth and nineteenth centuries were turbulent times on the world stage and cannons and cannonballs manufactured right here in Chesterfield were sent across the globe, causing death, destruction and shaping the course of history in the process on the battlefields of the American War of Independence and the Napoleonic Wars, among others – hence the popular name the building now goes under.

In 1886 the building was purchased by the well-known local packaging firm Robinson & Sons for £1,020, who used the waterwheel to drive machinery that recycled waste cotton into cotton wool. Over time their larger works have grown up

Below left: Another misleading datestone – the building is at least forty years older than this plaque would have you believe!

Below right: The waterwheel of Cannon Mill.

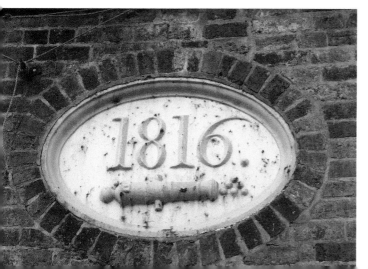

around the little mill, subsuming it somewhat. At the time of writing, the building is looking a little sorry for itself with felt sheeting placed over the roof, boarded-up windows and railings bent out of shape. Unlike with some surviving former watermill buildings, its waterwheel is happily still present, but becoming overgrown with ivy and its goit has turned a viscous pea soup colour and become a repository for litter.

17. Stone Edge Smelt Mill – *c.* 1770

Lead has been mined in Derbyshire since Roman times. Roman 'pigs' (ingots) of lead discovered in the Matlock Moor area in the late eighteenth century were found to be inscribed with the word 'Lutudarum', thought to be a location in Derbyshire used by the Romans as a central lead trading base. Chesterfield is thought to be the location of Lutudarum by some, other suggestions put forward being Wirksworth, Crich and Carsington.

This chimney, which occupies a rather desolate spot above Chesterfield on the moorland road to Darley Dale, is believed to be the oldest surviving freestanding industrial chimney in England, built around 1770. The Historic England listing register describes the Stone Edge site as 'one of the best preserved examples in England of a reverberatory smelt mill'. The output from the site around the turn of the eighteenth and nineteenth centuries was 500 tons of lead a year, but the Stone Edge Smelt had ceased operations by around 1860 meaning it had a working life of just under 100 years. The chimney remains and is in good condition, but the rest of the buildings have been lost to us, with some of the ruins buried under the dense bracken and a series of flues surviving as underground tunnels. Other

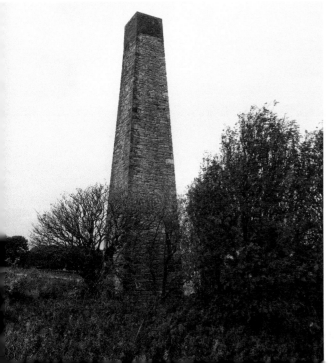

The chimney of Stone Edge Smelt Mill, thought to be the country's oldest surviving free-standing industrial chimney.

reminders of the site's industrial past are the pool used to power the bellows and the name of the road passing by the site, Belland Lane – Belland being a dialect word for the poisonous fumes produced by the lead smelting, which could seep into the ground and poison any nearby animals (and humans). The toxic nature of the workings was why such an isolated spot was chosen for their location.

18. Tapton House – 1782–94

Located on a hill 1.5 miles from the town centre, the elegant red brick Georgian mansion Tapton House was first built for Isaac Wilkinson of a local banking family who were also sponsors of the Chesterfield canal (opened 1777). The choice of the hillside location was strategic: by the eighteenth and nineteenth centuries, the higher ground to the north and north-west of Chesterfield town centre was becoming a fashionable area for the villas of the middle class, away from the prevailing smoky conditions created by the industrial activities conducted in the town centre.

While the architect is not known, architectural historians have noted a similarity in style to the work of John Carr of York (1723–1807), who designed Buxton's Crescent. Carr was active in Chesterfield in 1787–88, building a new Town Hall on the corner of Glumangate (now demolished).

Tapton House, former home of George Stephenson and the Markhams.

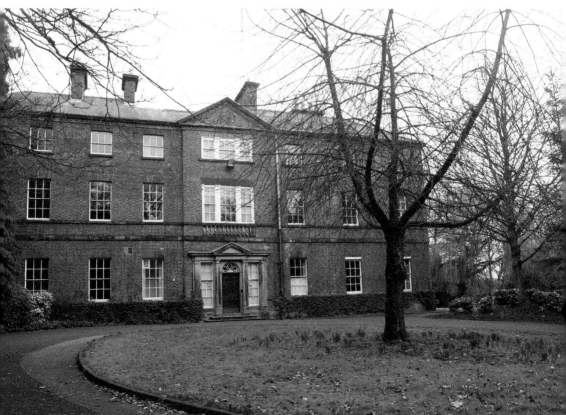

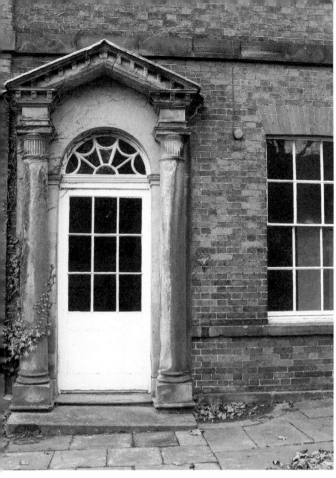

Left: Detail of doorway and sash window at Tapton House.

Below: Tapton House and grounds.

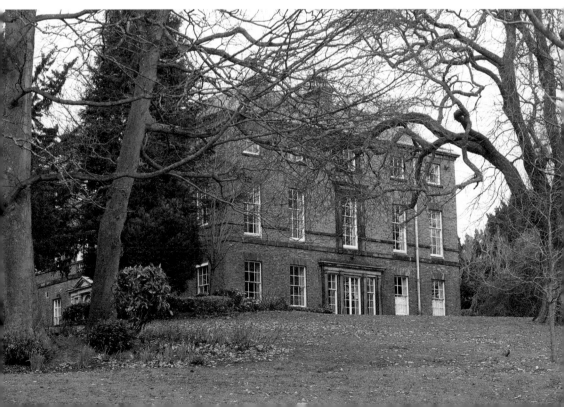

After Wilkinson's death in 1831, Tapton passed to his ward George Yeldham Ricketts, who leased the property in 1838 to railway engineer George Stephenson. Stephenson retired to Tapton where he was greatly content pottering in the greenhouses and gardens, experimenting with horticulture, which he displayed competitively at local shows, and observing the nature in the grounds (it is said he knew the location of every bird's nest on the property). Stephenson died in the house in 1848 and his son Robert kept the place on until his death in 1859. A short-lived spell as a high-class school for girls ensued, before the Markham family of industrialists moved in from their nearby previous home of Brimington Hall in 1871. Charles Paxton Markham (1866–1926) wrote to the Mayor of Chesterfield in 1925 offering Tapton House to the borough of Chesterfield, provided it be used 'for the benefit of the inhabitants of Chesterfield' and the 'pleasure grounds to be open to the public ... and they are always to remain as pleasure grounds and not to be built over'. The idea was mooted of turning the house into a museum and exhibits began to be accumulated, but this scheme fizzled out and again Tapton became a school, opening its doors to pupils in 1931 and closing sixty years later in 1991, when the building subsequently became part of Chesterfield College.

19. No. 87 New Square – Late Eighteenth Century

Another of Chesterfield's characteristic surviving town centre red-brick Georgian residences. The blue plaque on the wall would have us believe that this was the boyhood home of Thomas Secker (born in Sibthorpe, Nottinghamshire) who attended school in Chesterfield and went on to become the Archbishop of Canterbury between 1758 and his death in 1768 – the fatal flaw in this theory being that Secker was born in 1693, and this is clearly a building of a later vintage, late eighteenth century according to its listing record.

No. 87 New Square.

During this period this area of the town centre was developed with some new swish residences including No. 87. Prior to this process of gentrification the square it faces, which today holds the Bottom Market, was formerly the location of Chesterfield's regular pig market – hence it was known by the street name of 'Swine's Green'. No. 87, Swine's Green was clearly not viewed as a suitably elegant address befitting the newly built house, and the square was renamed the slightly unimaginative 'New Square', which it remains to this day. Although the address was prettified, the market and the pigs themselves remained, until the opening of the new cattle market on Markham Road, whose stone gate pillars remain beside the Ravenside Retail Park.

As happens to so many buildings which have outlived their original purpose, No. 87 New Square is currently slated to be turned into multiple-occupancy luxury apartments. The scheme by Leverson UK is due to be completed in 2020.

20. Former Weavers' Cottages at Rattle, Ashover – Eighteenth Century

The existence of 'sweatshops' in the supply chain of cheap fashion is sadly not a new phenomenon, it's just that in the pre-globalisation era they were located a little closer to home. A hamlet near Ashover has the unusual name of Rattle, which stems from a cottage industry practiced in these parts in the eighteenth and nineteenth centuries – stocking frame knitting. The locals installed the complex mechanised stocking frames on the attic floor of their cramped cottages – the name is believed to derive from the noise the rattletrap apparatus made when it was in full flow. In a business model still adhered to by the major budget fashion chains of today, a local entrepreneur would deliver the raw materials of silk and cotton to the cottagers and return to collect the completed stockings (and pocket most of the profits, paying the machinists a piecemeal rate).

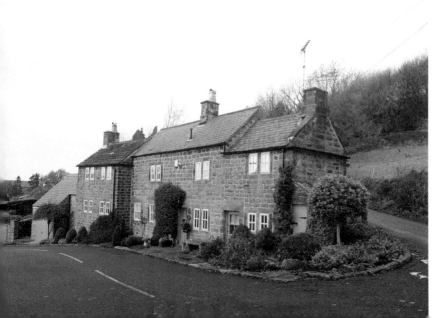

Surviving weavers' cottages at Rattle, Ashover.

Most of the weavers' cottages have now been demolished, but there are a few still standing at the junction of Chapel Hill and Hill Road. Ashover, up until the second half of the twentieth century a rather isolated community off the beaten track between Chesterfield and Matlock, has become something of a commuter's playground – a cottage on the village main street recently sold for £600,000.

21. No. 41 Low Pavement (formerly Castle Vaults) – Eighteenth-century Frontage/1981

The mid-1960s: the times they were a-changin' – even in Chesterfield and the offices of Derbyshire County Council's planning department. Britain was awakening from the black and white post-war years of extended rationing into a glorious technicolour revolution, which was to be forged utilising the white heat of emerging new technology. A 1965 'Redevelopment of Central Area' report into Chesterfield town centre compiled by town planners was brutal and unsentimental in its tone. Noting recent changes in the fabric of society including population growth, increase in overall living standards and the rise of the motor car, the report stated in no uncertain terms that sluggardly Chesterfield had not kept apace with these developments. The town centre, said the report, was 'threatened by obsolescence', its buildings 'decaying' and 'inadequate', its roads subject to congestion. In this mid-century mentality, the car was the transport medium of the future, a mindset that culminated in the Beeching cuts to branch railways – a move that, viewed from the early twenty-first century and a growing awareness of the ecological strains the planet is under, is now beginning to look staggeringly short-sighted. The 1965 report gleefully proposed a vision for Chesterfield that now sounds like a Balladian, dystopian nightmare: 'The plan proposes, by stages, to build up an almost continuous complex of multi-storey car parks around three sides of the town centre; giving ultimate provision for at least some eight thousand cars.'

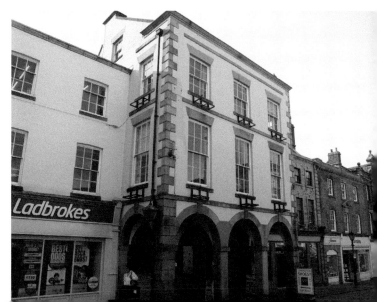

No. 41 Low Pavement façade (former Castle Vaults), showing some of the neighbouring shop frontages.

The 1980s Pavements shopping centre behind the eighteenth-century shop frontages.

Had these plans been carried out, it would have swept away many of Chesterfield's characterful historic buildings (and made compiling this book a far more difficult task, you would have been reading *Chesterfield In 8 Buildings* instead). Thankfully a coordinated campaign by heritage groups forced an eleventh-hour rethink, a compromise being reached where the characteristic old shop frontages were retained but the major portion of the buildings demolished and a modern shopping centre ('The Pavements') built behind and seamlessly knitted to the façades. In a sense this was history repeating itself as the properties along Low Pavement were originally burgage plots – houses on long, narrow plots of land, which would often contain small forges, pigsties, vegetable gardens, etc., behind. The ornate shop frontages were built onto these burgage plots at a later date. While surveying the buildings when they were under threat in the early 1970s, D. F. Botham found Jacobean oak panelling and cupboards still present in a room on the first floor of No. 45 Low Pavement.

While none of the buildings on Low Pavement and the Market Square were considered especially outstanding individually, together they were considered of sufficient 'townscape merit' to secure their saving. To illustrate this section I have chosen one of my own personal favourites, the former Castle Vaults, a wine and spirit, ales and cigars merchant.

22 and 23. Lodges to Somersall Hall (Nos 1 and 2 Somersall Lane) – c. 1800

In the early twentieth century, postcards were issued of the leafy lanes of Somersall, marking the area out as a semi-rural oasis that was still easily reachable from the town centre. Even in the early twenty-first century, the intersection of Chatsworth Road and Somersall Lane marks a distinct change of gear: the former busy with

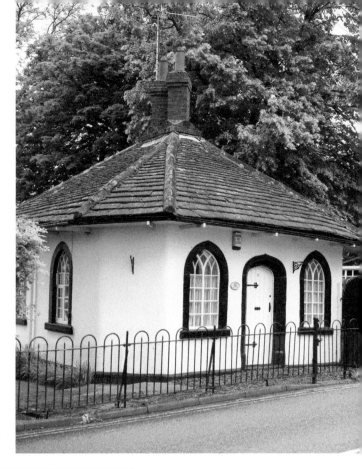

Right and below:
The characterful Gothic Revival
lodges to Somersall Hall.

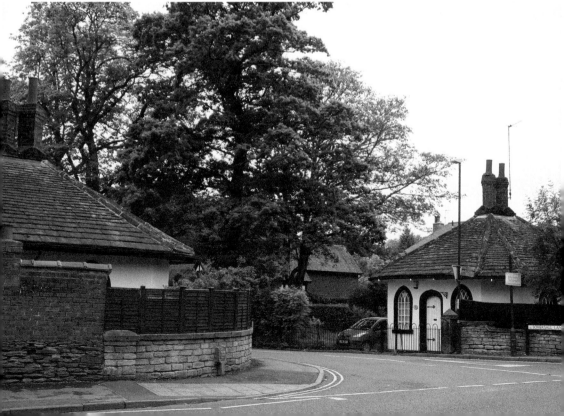

traffic, shops, factories and pedestrians; the latter quiet and lined with mature trees. Greatly adding to this sense of the town abruptly giving way to the country are the pair of charming lodges in the Gothic Revival style that are located at either side of the junction.

In former days a gate stood across the lane and the lodge keepers would have overseen the entrance and egress to Somersall Hall, located further up the lane and built in 1763 (on the site of, and incorporating elements of, an earlier house) for the Clarke family whose members variously served as High Sheriff of Derbyshire and Member of Parliament for the county.

In more recent times, the lodges – both now private houses – have been discreetly extended and modernised, but in the process have not lost their almost fairy tale quality. Similarly, the tree-lined Somersall Lane has been infilled with twentieth-century properties and now provides one of Chesterfield's most desirable addresses, but it is still easy to visualise the lane as a grand sweeping driveway and imagine visitors in days of yore being vetted at the lodges to assess their suitability for proceeding onwards to the hall to visit the Clarkes.

24. The Ragged School (built for industrial use *c.* 1830; became a school 1878)

As the town industrialised, a slum area of Chesterfield grew in the area between Low Pavement and the River Hipper. Notorious for overcrowding, poor sanitation and crime, it became nicknamed the 'Dog Kennels'. It was eventually swept away at the behest of industrialist and Mayor of Chesterfield Charles Markham, who took a philanthropic interest in the lives of local working people. The busy road that now thunders day and night with traffic through the location of the former Dog Kennels bears his name.

One of the few buildings in this area that survived the improvement scheme is the Ragged School.

In Victorian England, there were many Ragged Schools established as reforming organisations providing free Sunday school education to children in poor areas of industrial towns and cities.

By an 1837 map, the premises that were to go on to become the Ragged School had been built, most probably as a lace mill. By 1878, after several subsequent changes of use, the building was lying vacant. A crusading quartet of young men belonging to the nearby Soresby Street Congregational Church – Arthur and Henry Slack, Henry Shaw and Frederick Conroy – sensed what they perceived to be a developing moral vacuum on their doorstep and rented the upper floor to set up a Ragged School for the benefit of children of the area, throwing open their doors on Sunday 28th July 1878. The venture was immediately successful and soon expanded – by 1885, there were 340 pupils and 27 teachers. After nine years the organisers elected to buy outright the building they were still renting for their enterprise, and managed to raise the sum of £280 through fundraising, with a necessary further £200 coming from an anonymous benefactor.

Right and below: The Ragged School on Markham Road.

My grandmother Irene Bradley (née Frith) was a pupil at the Ragged School in the early years of the twentieth century. In later life she established a florist's a stone's throw away in the portacabins formerly located on New Beetwell Street.

25. Clay Cross 'Pepperpots' – 1837

There are nine of these curious constructions in total in and around the streets of Clay Cross, nicknamed locally the 'pepperpots'. They were built as ventilation shafts for the Midland Railway tunnel that was built as part of the construction of the Derby to Leeds railway line. While boring the tunnel, during which at least fifteen workmen were killed, George Stephenson who was heading up the operations struck it lucky when substantial quantities of coal, oil and ironstone were discovered in the ground; Stephenson with others subsequently set up The Clay Cross Company to exploit the mineral riches. The town rapidly expanded; before the railways came it was a small village of a few scattered stone dwellings located around a crossroads and known as Clay Lane.

In the era of steam railways, plumes of steam would billow up through the shafts and into the town as engines passed below – which must have been a dramatic sight. The pepperpots/shafts remain as a distinctive, eccentric and ever-so-slightly-phallic presence on the streets of this most unique of towns.

Another noteworthy feature of the tunnel is its Northern portal, designed by George and Robert Stephenson in conjunction with Assistant Engineer, Frederick Swanwick and built in 1837–39 in a dramatic Moorish castellated style with turrets and imitation arrow slits.

One of the Clay Cross 'pepperpots' with North East Derbyshire's answer to Hollywood behind.

Above left: Another of the Clay Cross pepperpots, built as ventilation shafts for the railway tunnel.

Above right: Standing proud: another pepperpot surrounded by public seating.

26. Holy Trinity Church – 1838

Construction of Holy Trinity began in 1837 (the foundation stone being laid by the Duke of Devonshire) to meet the spiritual needs of the expanding town, as congregations were packing out the Church of St Mary and All Saints to its crooked capacity.

While Chesterfield's parish church is well known for its twisted steeple, Holy Trinity also enjoys fame beyond its foremost purpose as a place of worship, for being the final resting place (the End of the Line) for one of Chesterfield's most distinguished residents, railway pioneer George Stephenson, who lived locally at Tapton House (QV). Stephenson appears to have not wanted much of a fuss after his passing, as his tomb, located in the floor behind the altar, is starkly austere, consisting simply of the initials 'G.S.' and the date 1848. 'I've had people come all the way from Australia to see it and then look at me as if I've swindled them,' Revd David Horsfall told me when he showed me around the church (in addition to his religious duties, his role as vicar encompasses tour guide for the legions of railway enthusiasts who come to the church in pilgrimage). Various subsequent parties have made attempts to highlight the burial place of the illustrious engineer – a nearby further stone tablet in the floor was installed by the Institute of Mechanical Engineers to honour Stephenson, who was their first president; a more ornate marble tablet on the wall in memory of Stephenson's second (of three) wife Elizabeth has had details of her husband's death subsequently added underneath; and an impressive stained

Above left: The tower of Holy Trinity Church.

Above right: Interior of Holy Trinity, showing the Stephenson memorial window at the back provided by his engineer son Robert.

Below: Understated: initials on the tomb of the great railway engineer George Stephenson.

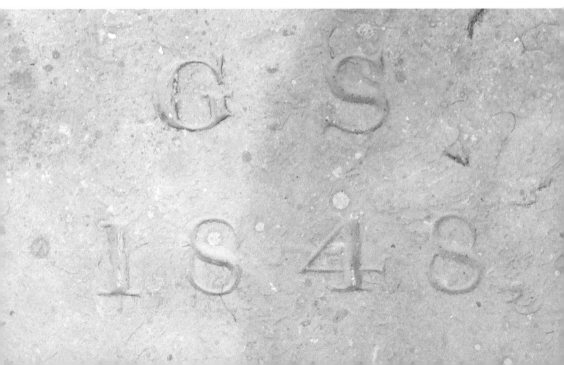

glass window in the chancel was installed in memory of Stephenson using funds provided by his son and collaborator Robert, featuring the initials 'GS' throughout the design. What at first glance might appear to be a fifth tribute to the railwayman, a stone column located just outside the main entrance door to the church, is a red herring: closer scrutiny reveals this to be the grave of the coincidentally named George *Stevenson* – note different spelling of the surname – who died in 1900, aged sixty-seven. Revd Horsfall's predecessor saw fit to have a stone tablet installed at the bottom of the namesake's grave stressing that 'the' George Stephenson is buried in a vault inside the church, to avoid confusion.

When not in use for services, the church is normally kept locked, but access is possible by prior arrangement; details can be found on the church website: http://www.holytrinityandchristchurch.org/

27. North Midland House – 1840

For a town so intertwined with the railway system (see also 18. Tapton House, 25. Clay Cross 'Pepperpots', 26. Holy Trinity Church, 33. Barrow Hill Roundhouse and 34. the Stephenson Memorial Hall), in my lifetime Chesterfield railway station has always felt a little underwhelming, with one uninspiring building replaced

North Midland House: of uncertain origins.

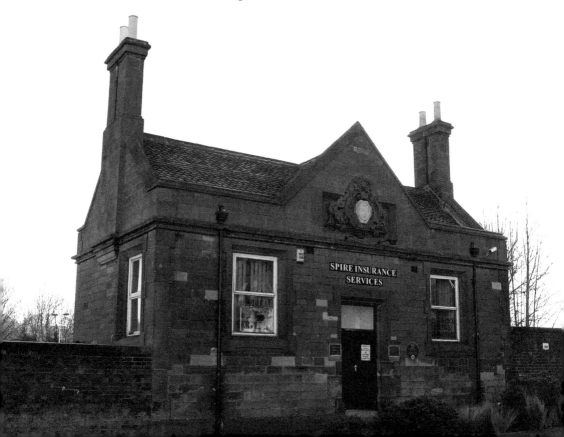

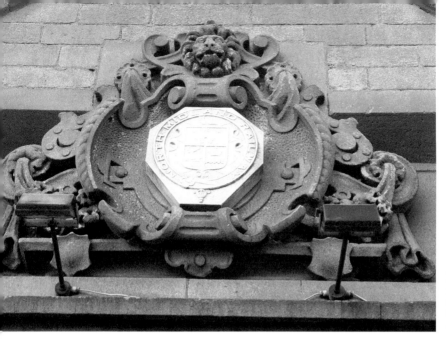

Arms of the North Midland Railway on the tympanum of the building.

with another slightly less inspiring one in 2005. A nod to the town's connection to George Stephenson is given with a statue of the man himself produced in bronze by Stephen Hicklin outside the main entrance.

Previously thought to be the sole surviving building contemporary to the town's original 1840 railway station, there is some confusion as to the original purpose of North Midland House, not helped by the fact that the road it now stands on, Corporation Street, did not exist in the 1840s. A map from this era records a 'machine house' (possibly a weighing machine), but its appearance, size and the number of chimneys suggests a dwelling, possibly an early house for the stationmaster. Whatever its purpose, the building still displays the arms of the North Midland Railway carved in stone on its tympanum.

Contradicting their blue plaque on the building itself, the Chesterfield Civic Society website thinks the building wasn't in fact built at the same time and speculates that it may have been relocated from elsewhere. What we can say with conviction is that at the time of writing it provides a base for the offices of Spire (what else?) Insurance.

28. Saltergate Terrace (Nos 69–79 Saltergate) – 1845–47

Saltergate was first recorded in 1285, its name suggesting to us that it probably formed part of an ancient trackway into Chesterfield leading from the salt plains of Cheshire to the west, which have been worked since Roman times. The street marked the final stage of the journey bringing the commodity across the country and into the town to be sold at the market. In more recent times, from 1871 until 2010 when the Proact Stadium opened, the ancient trackway brought football fans into the town to cheer on their team when matches were played at Chesterfield FC's Recreation Ground stadium, itself more commonly referred to as 'Saltergate'.

Right: Late developers: more handsome, characteristically 'Georgian' architecture in the town, which may in fact be Victorian.

Below: Saltergate Terrace and neighbouring properties with surviving carriage archway.

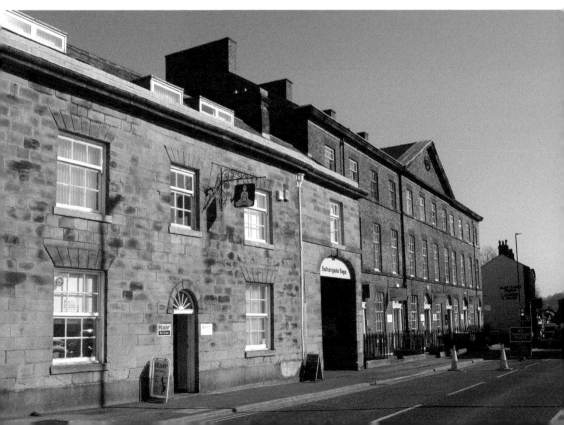

Nos 69–79 Saltergate is a large, handsome and characterful terrace. The Chesterfield Town Centre Conservation Area appraisal document prepared by the borough council comments of the houses in the row: 'They represent one of the most striking groups of buildings in the town and give the area a feeling of prosperity.' The terrace consists of six houses overall of two bays apiece, but are now used for office rather than residential use.

I have consulted various sources regarding the dating of the terrace in order to place it in the book in the correct chronological sequence, but on this point no one seems to agree. The Historic England listing entry (the building is Grade II* listed) dates the row to late eighteenth century. The Conservation Area appraisal goes with early nineteenth century. Pevsner thinks it '*c.* 1830 but still Georgian', comparing it to No. 23 West Bars, also dated to *c.* 1830 and described as 'but completely in the Georgian tradition, which lasted until late here'; he seems to be implying that Chesterfield is slow on the uptake when it comes to picking up on trends happening outside the town in the wider world (surely not!). Chesterfield Civic Society, in a report in response to Chesterfield Borough Council's draft Local Plan of 2017, pinpoint the construction of terrace later still to 1845–47, also supplying a protagonist: William Rooth, a timber merchant who lived at No. 81 Saltergate and built the row next to his own house. Given that the Civic Society are armed with the most local and specific knowledge and are in general experts in such matters, I have gone with their dating.

29. West Studios (former Chesterfield Grammar School) – 1846 with later additions

While there was a school of some form in the town by the thirteenth century, Chesterfield Grammar School's pedigree dates back to *c.* 1598 following a bequest left by Godfrey Foljambe of Walton on his death in 1594. In the eighteenth century a large number of pupils from the school went on to Cambridge University, but then the school entered a period of decline, closing in 1832. It was to reopen in 1847 based at these premises on Sheffield Road.

In 1967 the Grammar School moved out to newly built premises at Brookside, the buildings on Sheffield Road subsequently becoming part of Chesterfield College, since 2014 being styled as West Studios, which in addition to college facilities also contains workshops, a café, offers business support to the local creative community including a gallery and shop selling locally produced artwork and crafts, and is the home of *S40* magazine, which reports on local matters. The Grammar School at Brookside closed in 1991, a victim of the local education reorganisation of that year. Famous former pupils include Erasmus Darwin (grandfather of Charles, physician and founder member of the Lunar Society of Birmingham) and Tom Bailey (member of pop group the Thompson Twins).

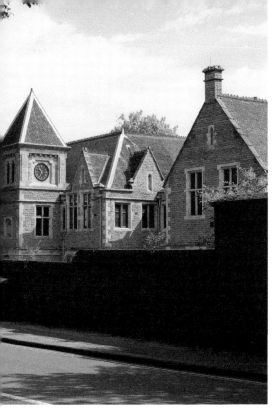
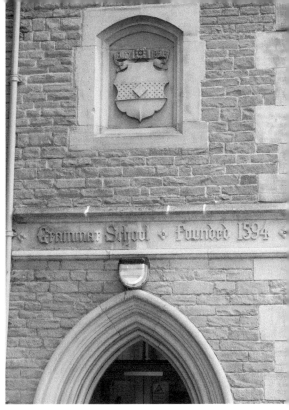

Above left, right and below: West Studios, former premises of Chesterfield Grammar School.

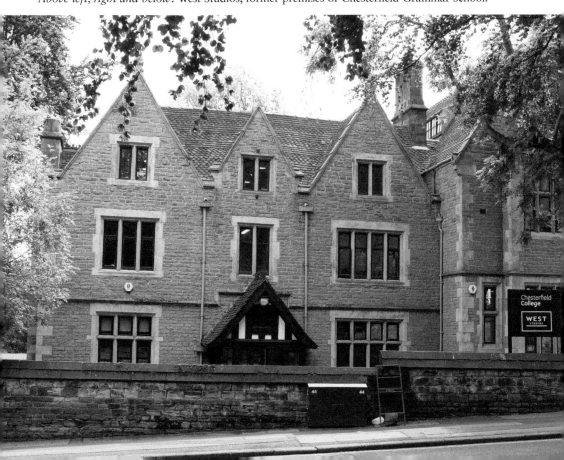

30. Market Hall – 1857

Chesterfield was granted its market charter in 1204 (although a market is likely to have already been in existence by this date), and in spite of changes in shopping habits in the intervening 800 years the town's market remains a focal point which inspires much pride, passion and nostalgia among locals.

An earlier Market Hall existed prior to the current building, but was of fairly ancient origin and by the nineteenth century had become dilapidated so more modern facilities were desired 'for the shelter and safeguard of market people' and for the benefit of the town's shoppers on days of poor weather. In 1857 the Market Hall we see today opened its doors, boasting multipurpose facilities including a Corn Exchange (demolished in the 1970s and replaced by a modern extension), covered market, shops, offices, Assembly Rooms, county courtroom, post office, library and accommodation for the market keeper, as well as Chesterfield's first public toilets, or as they were genteelly styled in the coded language of Victorian Britain, a 'retiring room for ladies'.

Despite the new facilities the building brought to the town, one person who was resolutely not impressed with the Market Hall was the well-known sniffy architecture critic Nikolaus Pevsner, who dismissed the building in seven words as 'The crudest show of High Victorian prosperity' in his architectural survey of

Below left: Crude and showy or award winning? You decide.

Below right: The Market Hall's clock tower.

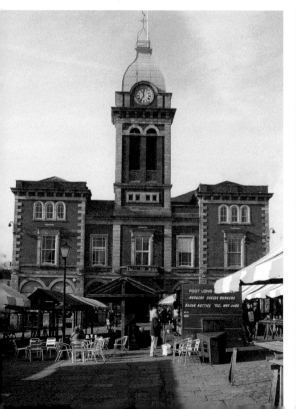

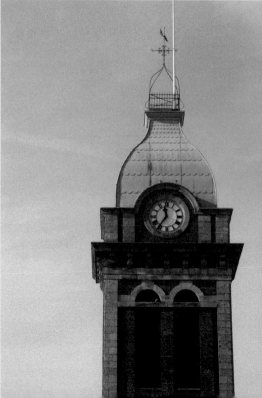

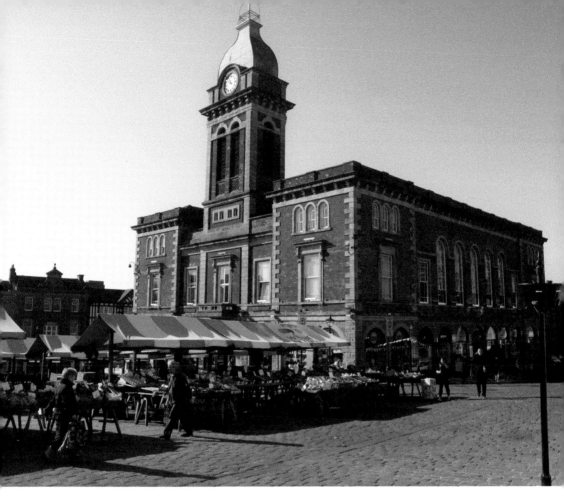

The Market Hall and Chesterfield's outdoor market, which occupies a firm place in the hearts of townsfolk.

Derbyshire. By the late 1970s, the building had seen better days, having become severely smoke blackened by the high volume of industry carried out in the town. A programme of renovation works and cleaning took place concurrent with the building of The Pavements shopping centre, bringing the building back to its former glory. Botham (2004) records that during this 1970s renovation, workmen discovered an especially grim form of naturally occurring cavity wall insulation, which had filled what should have been the gaps in 15-foot-high partition walls on the upper floors – a century's worth of pigeon carcasses, cemented together by their successors' droppings.

Within a generation, the Market Hall was again beginning to look tired. A further £4 million programme of renovations and modernisation was undertaken by the borough council in 2013 with money provided by the council, Heritage Lottery and European Union – which all seems to have paid off, as that year the building scooped the hotly contested 'UK's Best Small Indoor Market' award as chosen by the National Association of British Market Authorities.

31. Spital Cemetery Lodge – 1857

By the mid-nineteenth century the population of Chesterfield had rapidly grown, driven by the industrial expansion of the town. More people living in Chesterfield conversely meant more people dying in Chesterfield, and the existing churchyard burial grounds were becoming overcrowded and unsanitary. There was also a high number of Nonconformist worshippers in the town, who required alternative burial arrangements in unconsecrated ground.

The solution was the creation of Spital Cemetery, which opened in August 1857, Derbyshire's second public cemetery after Derby. In May 1856 a competition was held to design the buildings required to complement the cemetery – a lodge, the entrance gates, and two cemetery chapels. Thirty-six designs were submitted, with Wolverhampton-based architects George Bidlake and Henry Lovatt securing the winning scheme.

The first four burials in the cemetery were, tragically, all children aged under one year, a sad reminder of the infant mortality rates of the time. Death being the great leveller, some of Chesterfield's most prominent citizens (including Frederick Swanwick, the Stephenson's close contributor on several engineering projects; coal mining MPs James Haslam and William Edwin Harvey, whose statues are outside

Spital Cemetery Lodge.

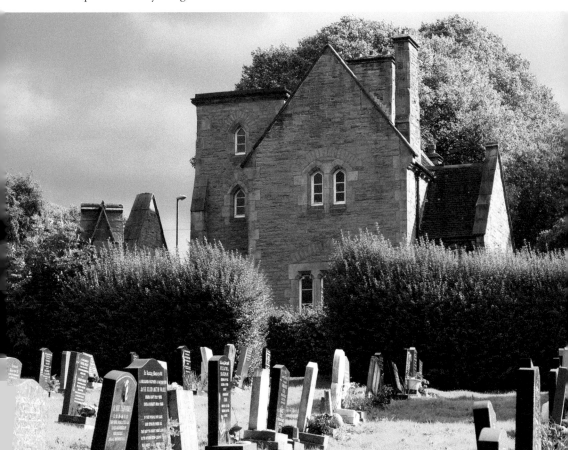

the Derbyshire Miners Association Offices; photographer Charles Nadin; and T. P. Wood, mayor, spirit merchant, almanac compiler and prime mover behind the creation of Queen's Park) are here laid to rest among those who lived humbler existences.

The lodge is now a private house, presumably occupied by inhabitant(s) not bothered about the comings and goings of mourners or squeamish about having a cemetery for a back garden. Although even with normal gardens, occasionally surprises can occur. Spital gains its name from the presence of a ho*spital* dedicated to St Leonard formerly located close to the cemetery that provided care to lepers. In 2001 during building work on a nearby house on Hady Hill a skeleton thought to belong to a twelfth-century priest who served at the hospital was discovered buried in the garden. He was brought to Spital Cemetery to be reinterred and a headstone marks his new resting place.

32. Barlborough Memorial Arch – 1869

Bringing an unexpected dash of the exotic to north-east Derbyshire, this unusual archway in the village of Barlborough was built in 1869 by William Hatfield de Rodes of Barlborough Hall as a memorial to his wife Sophy Felicite de Rodes, who died that year at the early age of thirty-four.

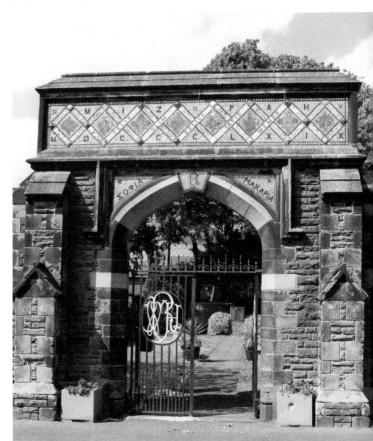

Barlborough Memorial Arch.

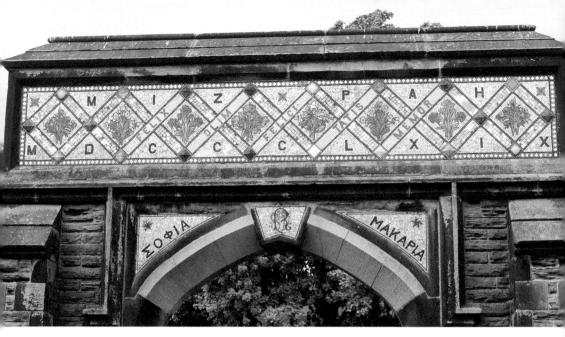

Barlborough Memorial Arch.

The arch is known locally as the 'Golden Gates', and the gilt and mosaic work are still vibrant and in good repair. It contains inscriptions in three different languages: Hebrew, Latin and Greek. Along the top is a Hebrew word meaning a sanctuary, lookout or watchtower, 'MIZPAH', interpreted figuratively to mean an emotional bond linking people who have become separated, either at a geographical distance or as in the de Rodes' case through death. Along the bottom is the year of Sophy's death and the subsequent construction of the arch rendered as Roman numerals, MDCCCLXIX. The Greek and Latin inscriptions both punningly play off Sophy's first and middle names, 'SOPHIA MAKARIA' translating as 'dearest wisdom' and 'FELIX/OLIM/FELICITATIS/MEMOR' meaning approximately 'once happy man mindful of past happiness' referencing Felicity. Clearly William liked playing with language and put a great deal of thought into the planning of this tribute.

In 1951 a Garden of Remembrance containing a war memorial was created behind the archway to commemorate the local dead of the two world wars. Barlborough contains many further characterful old buildings, including Barlborough Hall of 1583–84 (now an independent Catholic school), the village cross topped with a sundial, the late sixteenth-century Old Hall and an almshouse of 1752.

33. Barrow Hill Roundhouse – 1869–70

Barrow Hill developed when George Barrow and his brother Richard took on the running of a forge near Staveley around the time that the railways were beginning to open up the country. The area was rich in coal and ironstone and by 1862, by which point Richard had taken sole control of operations, he was presiding over the largest colliery in Derbyshire. In 1863 the business became the Staveley Coal and Iron Company.

Above: Barrow Hill Roundhouse.

Below: Locomotives having a spin on the turntable at Barrow Hill Roundhouse.

Notice to Drivers, Firemen, Fitters, Steamrisers, and others concerned.

CASUALTIES TO ENGINES, AND DELAYS TO TRAFFIC ATTRIBUTABLE TO CARELESS WORKING ON THE PART OF THE STAFF.

Several cases of time lost by engines have lately been brought to my notice as having been due to careless and unsystematic working on the part of the Running Staff owing to mismanagement of fire, careless examination by the Driver when putting the engine away or by a Fitter who examines it subsequently, want of proper attention to the lubrication on the part of the Driver, etc.

It must be plainly understood that these offences, when proved come under the Truck Act, and not only are they punishable by fine as careless work, but this fine will in future, be inflicted, and in the event of any man having many fines against him shewing continuous careless work, he will be removed to less important and lower paid work.

R. M. DEELEY.

MIDLAND RAILWAY.

NOTICE.

Movement of Engines in Locomotive Yards.

PROTECTION FOR MEN WORKING ON THE ASH-PIT OR COAL STAGE LINES.

In future, men working on either the Ash-Pit or Coal Stage Lines must exhibit a Red Flag in daylight and a Red Light during darkness at each end of those lines for their own protection.

The signals will apply to BOTH lines, and before passing them drivers must satisfy themselves that any man at work in the vicinity is clear of the line on which the engine is about to move.

General Superintendent.

Rules and regulations, Barrow Hill Roundhouse.

An engine shed was built near Barrow Hill station in 1865 that could accommodate four engines. In 1866 the Midland Railway signed a mutually beneficial agreement with Staveley Works' whereby they purchased and would operate the works' internal private railway for 100 years. The subsequent increase in railway traffic necessitated a much larger engine shed being constructed. The works were able to take advantage of being part of the national railway grid to send their output further distances and faster.

The site was closed by British Rail in 1991 and threatened with demolition. After becoming subject to heavy vandalism, a Grade II listing was awarded, and the building was purchased by Chesterfield Borough Council in 1996. Now run as a working heritage asset by Barrow Hill Engine Shed Society, it is open to the public on Saturdays and Sundays from March through to December, and you can come along to watch their fleet of preserved locomotives being rotated on the turntable if that's your thing – it being a unique facility in that it is the only remaining roundhouse in the United Kingdom with an operational turntable.

34. Stephenson Memorial Hall – 1877–79

By all accounts the Northumbrian George Stephenson thought very warmly towards his adopted home town; and Chesterfield thought with great fondness and pride of their illustrious adopted son. After his 1838 death a public subscription was established to build a lasting memorial to the great engineer in the town, which he had settled down in to retire.

As befits a self-made man who knew the value of education, the hall was a centre for learning for the benefit of the townsfolk, according to the deeds 'for Scientific and Literary purposes'. It contained a museum, public library, laboratory, Mechanics Institute and public lecture hall accommodating 850 people, with lectures being given by Revd John Magens Mello and Edward Carpenter. Both led interesting extra-curricular lives. Mello was the rector of St Thomas' Church, Brampton, and also a noted archaeologist, conducting excavations at Creswell Crags (15 miles from Chesterfield), where together with William Boyd Dawkins he discovered the first piece of portable cave art found in Britain. Carpenter was a far more colourful character, and very ahead of his time in his beliefs, which included vegetarianism, communal living and gay rights – Carpenter was very much 'out and proud'. As a sideline Carpenter sold vegetables from his garden at Chesterfield market.

Below left: A memorial to Chesterfield's most famous adopted son – the Stephenson Memorial Hall.

Below right: Architect's drawing of the Stephenson Memorial Hall.

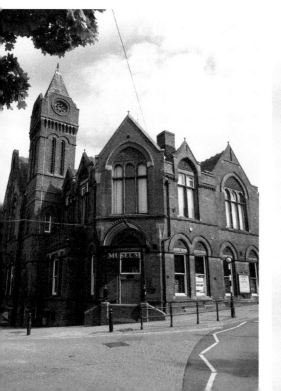

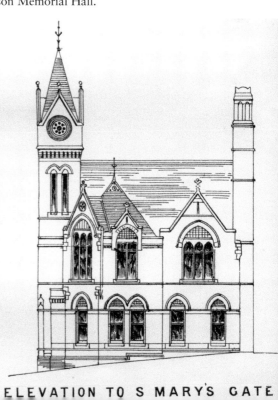

ELEVATION TO S MARY'S GATE

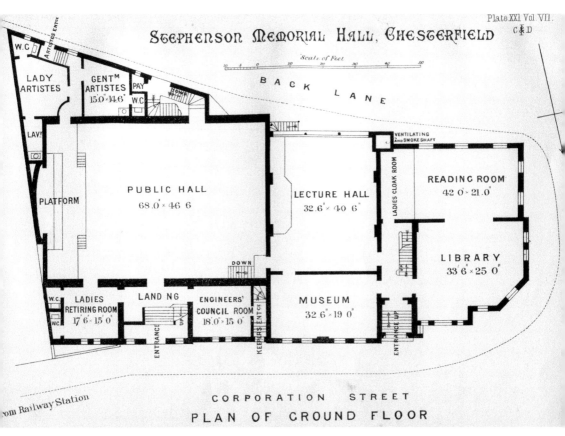

Architect's plan of one of the floors of the Stephenson Memorial Hall, showing some of the facilities.

The 540-seat Pomegranate Theatre opened in the building on 19 February 1949, making it the country's oldest civic theatre. Well-known actors who trod the Pomegranate's boards in their early days in rep include Peter Sallis, Penelope Keith, Wilfrid Brambell, Diana Rigg and David McCallum. The theatre was refurbished in 2014 with money coming from Chesterfield Borough Council and the Arts Council.

35. New Bolsover Model Village – 1891–96

For much of the nineteenth and twentieth centuries, coal mining was synonymous with the Chesterfield area, providing employment for generations of local people. By 1929, over 50 per cent of the male labour force of Chesterfield were employed in the mining industry. Markham Pit was the final colliery in Derbyshire to close, in 1994. The location of many collieries have been subsequently redeveloped, although sadly none have been retained for heritage purposes as at Overton near Wakefield, where the former Caphouse Colliery site was selected to be reimagined

as the National Coal Mining Museum. Tangible reminders of the mining industry remain across north east Derbyshire through some of its buildings – there are the several Miners' Welfare Clubs, catering to the former mining communities. In addition, there are the swathes of specially built housing constructed for the mine workers and their families.

This was a part-benevolent, part-political move on the part of the mine owners and heads of other such large manufacturing operations, e.g. the works at Staveley, Barrow Hill, Clay Cross and Sheepbridge (several of whose figureheads were outspokenly anti-union). All these companies shared a recurring problem: that of retaining a reliable workforce. All solved it in a similar way – by building 'model' villages of housing and infrastructure in the form of schools, chapels, pubs and community halls as a support network for the home lives of their workforce. This was textbook paternalism: the methodology being the workers' homes and jobs were intertwined to such a degree, there was less chance of them massing together on strike, speaking out against the company or failing to turn up for work given that doing so ran the risk of their families being evicted.

In an 1872 report, housing in Chesterfield was described as 'thoroughly bad'. By 1919 the situation had worsened with deteriorating buildings and overcrowding – especially in the notorious 'Dog Kennels' area – and 1,600 houses in the town were declared 'unfit for human habitation'. The model villages by comparison provided far more spacious and sanitary living conditions than the overall standards of the time.

Below left and right: New Bolsover: the 'Model Village' built to house miners and their families.

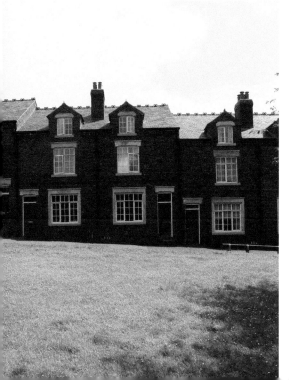

New Bolsover (known locally as the 'Model Village' or simply the 'Model') was built to house the workers of the Bolsover Colliery. The architects were Nottingham-based Arthur Brewill and Basil Baily, who created an attractive layout around a large 'village green' type space. The 194 houses each feature decorative details on the brickwork and on the rooflines. To the rear of the houses the walled backyards have a very *Coronation Street* vibe. Amenities for the miners and their families included a Co-operative stores (now closed), primary school and cricket pitch. A tram track ran from the colliery to the village and delivered coal to the coal store behind the houses, and as a sideline the local collieries branched out into brick production using their own coal and the quality clay found beneath the coal seam – Grassmoor Colliery's output was 14,000 bricks a day at one stage.

At the time of writing, the 'Model' is subject to a two-and-a-half-year, £10 million regeneration scheme managed by Woodhead Construction to regenerate the estate and restore original features – for example fitting new cast-iron guttering and drainpipes.

Stonework on the estate's former Co-operative stores, now closed.

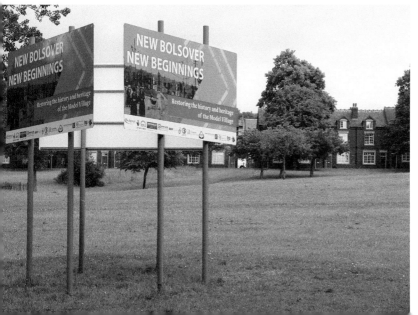

'New Bolsover, New Beginnings': the Model under regeneration.

36. Derbyshire Miners' Association Offices – 1893

The Derbyshire Miners' Association was founded in 1880 in a split from the South Yorkshire Miners' Association (formed in 1858 in Barnsley, who originally also represented Derbyshire). It aimed to provide support to the large numbers of people across the county employed in the industry, although only managed to establish a strong base in north-east Derbyshire, and a separate South Derbyshire Miners' Association was formed in 1888. In 1945, both associations were amalgamated into the National Union of Mine Workers.

To begin with, the association met wherever it could find space, including at The Falcon Inn (QV). This was not an ideal situation, and the rules of the association upon formation had decreed that, 'The general business of the Association shall be carried out at Chesterfield … where there shall be offices for that purpose.' In 1889 a building fund was established, and land at Saltergate was secured in

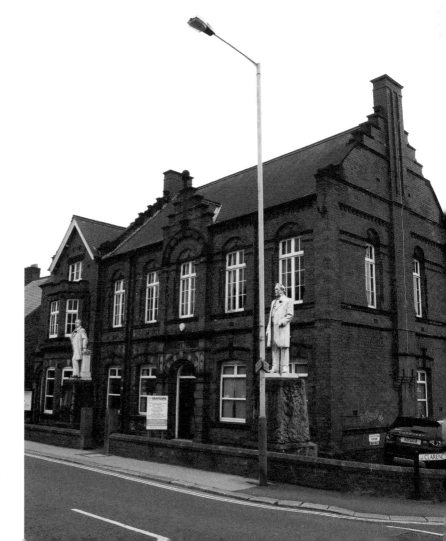

The former Derbyshire Miners' Association Offices on Saltergate, now Grayson's solicitors and a physiotherapist.

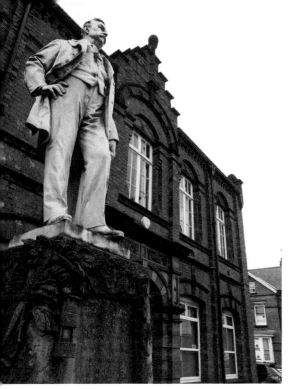

Above: Best not to risk it.

Left: William Edwin Harvey, coal miner, union official, MP and distant relative of the author.

1891 for the sum of £400. The handsome, yet restrained, offices were built for the relatively modest sum of £2,000 by Chesterfield-based architects Rollinson and Sons as permanent offices for the union with accommodation for the secretary. The style was deliberately understated in order to nip in the bud any suggestion that union funds had been lavished on unnecessary ornamentation. The opening ceremony took place on 24 June 1893, a proud occasion for the town.

In 1996 the building was turned down for listed status, but Chesterfield's indefatigable socialist former MP Tony Benn stepped in and asked for this decision to be reconsidered. Following a favourable report prepared in response for English Heritage by Susie Barson, a Grade II listing was subsequently secured in 1998. Barson's report concluded that the building's 'subdued Flemish Renaissance style aims to achieve a balance between pride and prudence' – a very Chesterfield kind of mentality.

Outside the offices are found the statues unveiled in 1915 of James Hallam and W. E. Harvey, both former miners themselves who went on to become involved in the Derbyshire Mine Workers' Union and subsequently Members of Parliament for Chesterfield (Hallam) and North East Derbyshire (Harvey). One or both statues can frequently be seen sporting traffic cones in various places about their person, adorning them in this way apparently having become a post-closing time rite of passage for Chesterfield pubgoers. I recently discovered that I am related to William Edwin Harvey, the Harveys being my dad's mum's side of the family. But when someone recently posted a picture of the statues to the 'Old Chesterfield Pics' Facebook page, judging by the comments it drew in response, it seems that half of Chesterfield believe themselves related to either one or the other.

37. University of Derby Chesterfield Site (former St Helena School for Girls) – 1909–11

The Chesterfield Girls' Grammar School was first established in 1892, originally based in existing premises at East Bank, Sheffield Road, before moving to a purpose-built site nearby begun in 1909 and completed 1911. Unfortunately, the school's first headmistress, Miss Wilkes, died in 1910 before the new site was finished.

The architect for St Helena's was the Norfolk born and bred George H. Widdows (1871–1946) who in 1897 secured a job as chief architectural assistant at Derby Corporation (as the city council was then called). In 1904, the same year he was elected an associate of the Royal Institute of British Architects, Widdows transferred to the job of building surveyor for Derbyshire County Council's Education Committee. In 1910, he was promoted to the council's chief architect, in a period which coincided with a massive expansion of school building, driven by the industrial expansion of the nineteenth

Above: Detail of stonework on St Helena School.

Right: The elegant St Helena School for Girls, now part of the University of Derby campus.

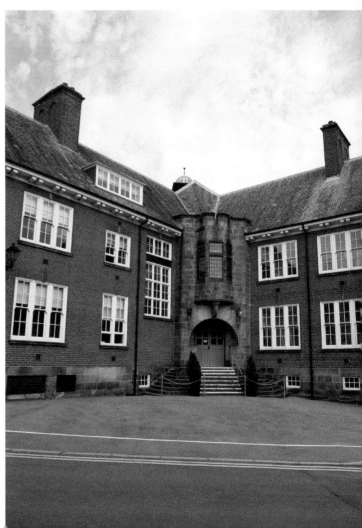

century, which had seen large numbers of families move from rural areas to towns to follow the new employment opportunities – Derbyshire saw the largest percentage increase in population in any English county in the 1890s, owing to the growth of the coal mining industry in the east of the county. By the time of his retirement in 1936, as well as St Helena's, he had constructed almost eighty primary and secondary schools across Derbyshire, including Lady Manners at Bakewell, the primary school on the New Bolsover (QV) development, Darley Dale Primary, Palterton Primary School, Tupton Hall School, Whittington Moor Infants School, and two schools at Staveley, which have now been demolished (as well as the public library there).

Widdows put considerable thought into his school designs, which were a break from the austere Victorian school board designs that had prevailed up to that point. Consulting closely with the county council's medical officer, Widdows incorporated elements into his plans designed to improve the health of the buildings' users, including large windows allowing in copious natural light and wide corridors that could be used for exercise drill in bad weather. The St Helena's buildings use locally made bricks from the 'Wasp's Nest' brickworks based at Brampton, and was a tricky site to plan in view of its steeply sloping nature.

Like the school in Tapton House and the Grammar School, St Helena's closed in the local education reorganisation of 1991. After a spell of use as administrative offices by Derbyshire County Council Education Department, in 2016 the site opened after renovation works as a Chesterfield-based outpost of the University of Derby. It received a Grade II listing in 1977.

38. The Victoria Complex – 1923–30

In 1913, Chesterfield councillors found themselves pondering a problem that would again resurface to trouble their successors fifty years later (see 21. No. 41 Low Pavement) – how to modernise the existing sub-standard layout of the town centre, which to a large degree still conformed to the narrow grids of the medieval street patterns, and make it more user-friendly for the shoppers of the early twentieth century? The council drew up a large-scale redevelopment scheme involving demolishing buildings, widening existing roads and building new ones, which had to go all the way to Parliament for approval. The government rubber-stamped the plans in 1914, but the outbreak of the First World War that year meant that the scheme had to be put on the back burner.

According to local lore the distinctive Tudorbethan appearance of the buildings that resulted when the scheme got back off the ground again in peacetime was as a result of a visit by the council to Chesterfield's near-namesake, the ancient city of Chester with its characterful old 'rows' (some of which are authentic thirteenth-century premises, while others are Victorian replicas). Pevsner for one

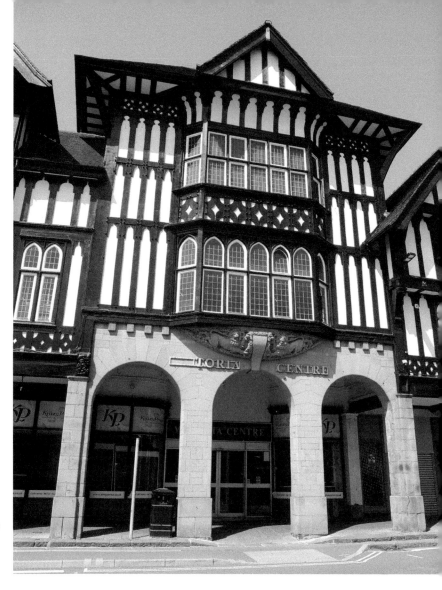

The colonnades and mock-Tudor timbers of the Victoria Centre, Knifesmithgate.

was not impressed with Chesterfield's borrowing from another town, decrying the 'ruthlessness Chesterization of Knifesmithgate'. However, as Janet Murphy explains on a website compiling Chesterfield's black and white buildings, it wasn't originally the half-timbered aspect of Chester that Chesterfield Council sought to replicate, rather the colonnades, which were designed to provide shelter for shoppers during poor weather.

Despite its olde-worlde appearance, upon completion the Victoria complex certainly lived up to its brief of providing up-to-date facilities for the townsfolk, consisting as it did of a ballroom, cinema, café, billiard hall, shops and bank. Passers-by are surveyed from on high along the stretch of the Victoria Complex by a sequence of figures, often grotesque, carved in wood. These are the work of Frank Tory and Sons of Sheffield and are an interesting detail of the building that are easy to miss, especially now most of them have recently been painted over in black paint.

Detail of the building showing some of the Frank Tory & Son carvings.

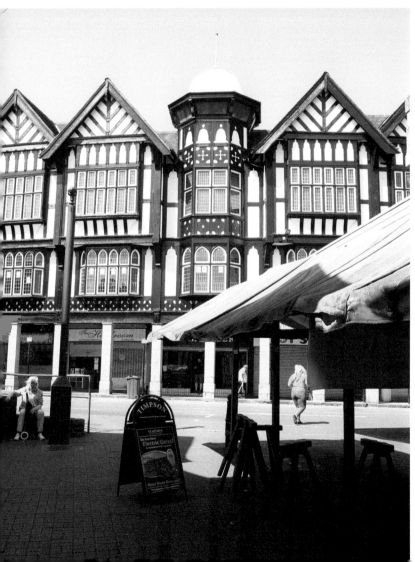

The Victoria Centre.

Chesterfield has over forty other black and white buildings, although no two are the same. Others in a similar style can be found elsewhere on Knifesmithgate and on St Mary's Gate, Lordsmill Street and Holywell Street, and collectively they contribute greatly towards giving Chesterfield town centre a distinctive and quirky look, as well as paying homage to the town's more authentic timbered buildings like the Royal Oak and The Peacock (although the timbered part of the latter building was hidden and forgotten at the time the ersatz black and white buildings were being constructed). *Chesterfield's Black and White* Buildings, a leaflet produced in 2015 by Chesterfield and District Local History Society and usually available from the Tourist Information Office or library, explores their heritage and contains a trail to follow.

39. The Winding Wheel (originally Chesterfield Picture House Cinema) – 1923

Another of Chesterfield's prominent black and white Tudorbethan buildings, the Winding Wheel originally opened in 1923 as a cinema, the Picture House, the premises also featuring a ballroom and restaurant. The very first films shown there on opening night were the romantic melodrama *Hearts Aflame* supported by the Buster Keaton short *The Play House*. In 1936 it became part of the Odeon circuit, keeping its original name at first before being renamed the Odeon in 1938.

Like many of the early cinemas, the Picture House employed architecture and interior furnishings to create a lavish atmosphere, styling a visit to the cinema as a sophisticated experience. Its interiors are far more opulent than the exterior, including a proscenium arch; rich carvings including Green Man-type heads and a decadent scene of dancing female figures, fauns and the ancient Greek god Pan entwined with garlands; and a large stained-glass dome over the dance floor of the ballroom.

In 1969 the restaurant closed, being painted red and converted into the Fusion Disco. By the early 1980s with the prevalence of televisions in homes, the cinema had become unprofitable, and was closed in 1981, the café and nightclub limping on for a few more years. In 1987 Chesterfield Borough Council bought and renovated the building, converting it into a live music, entertainment and conference centre – a worthy asset for the town, which brings in a varied programme of touring acts. The name of the venue comes from a prominent exhibit at Chesterfield Museum located across the road in the Stephenson Memorial Hall (QV), the medieval builders' wheel, which is over 600 years old and was used in the construction of the Crooked Spire to raise heavy building materials up the spire in an era before cranes. Essentially a giant version of those little wheels used to amuse and exercise hamsters in their cages, the materials were tied to a long rope attached to the wheel that a person then stood inside and trod around to wind the supplies up to where the builders were working.

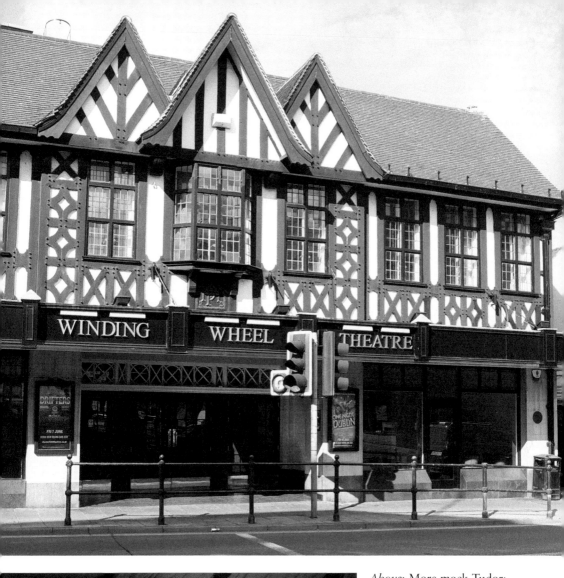

Above: More mock-Tudor:
The Winding Wheel.

Left: One of the lavish
interior carvings inside The
Winding Wheel.

Leaded fanlight still displaying the Chesterfield Picture House logo and former entrance to the restaurant.

The Winding Wheel was awarded Grade II listed status in 2000, its listing analysis noting that it was 'Included as a rare and elaborate 1920s' cinema complex, its decoration largely unaltered both externally and internally in its adaptation to new uses.' A little surprisingly for a building that is less than 100 years old, its origination appears uncertain, with the listing record only committing to saying that the architect was 'possibly' H J Sheppard of Sheffield and that the ballroom block was 'possibly' a later addition of circa 1930 (according to Hornsey (1992), Sheppard was specifically the architect for modifications to the building in 1930, which were driven by the installation of sound equipment to facilitate 'the talkies', so the original 1923 building may have been the work of someone else).

40. Burton Buildings – 1931

As the Burton Menswear chain expanded across the UK in the first half of the twentieth century, it consciously employed architecture as part of its branding, with Leeds-based architect Harry Wilson fashioning a distinctive storefront look in the art deco styling then in vogue to promote a sense of sophistication – the idea being that its clientele would feel by shopping there the inherent classiness would rub off onto them.

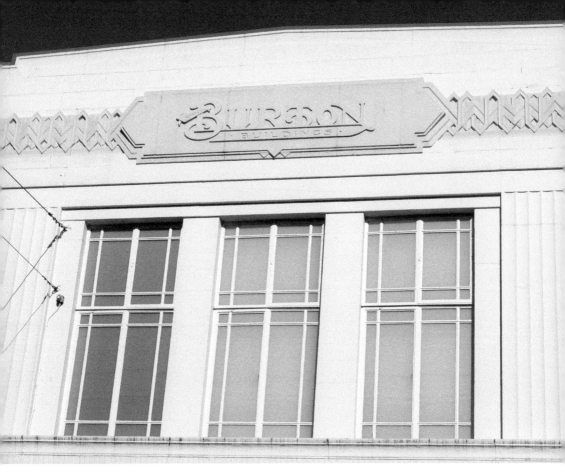

Burton Buildings, Burlington Street.

In Chesterfield the Burton buildings located on Burlington Street have an added significance, as it was here in the town that the successful chain was established, when founder Montague Burton – or Meshe David Osinsky as he was originally named – set up shop (initially under the less-snappy title of The Cross-Tailoring Company) at No. 20 Holywell Street in 1904, having fled Lithuania four years previously to escape Russian persecution.

A whimsical publicity stunt devised by Burton/Osinsky was the act of frequently coercing one of his four children – Barbara, Stanley, Arnold and Raymond – to lay the foundation stone when a new store was under construction. It was Stanley and Barbara who did the honours for the new Chesterfield branch, in 1931, and the stones can still be seen in situ.

Like many successful high street chain stores born in the pre-internet world of the twentieth century, Burtons has struggled in the cut-throat economic climate of the early twenty-first, and in 2016 they vacated the premises. The budget pasty empire Greggs are the current tenants of Nos 8–12 Burlington Street, with a sister branch a few doors down at No. 38 Burlington Street. Whether the psychology of Wilson's architecture is sufficiently powerful after the change in the building's use that the clientele still leave the premises surrounded by an aura of sophistication now the products vended within are steak bakes and sausage rolls is something that is difficult to determine.

Foundation stone laid by Montague Burton's son Stanley.

41. Chesterfield Town Hall – 1935–38

Chesterfield had a number of previous municipal buildings, including a Council House built in 1620 close to the historic bowling green, a 1787 Town Hall with cells and courtroom designed by John Carr and built on the corner of Glumangate on the site now occupied by the Midland Bank, and a new Council House of 1850 on New Beetwell Street around where the library now stands. By the early years of the twentieth century, after the borough had expanded to encompass Hasland, Brimington, Brampton and Whittington, a more substantial building was required to carry out the all-important business concerning the running of the town.

The current elegant Town Hall, which oozes civic pride, was designed by the A. J. Hope of the vaguely music-hall-turn-sounding practice Bradshaw, Gass and Hope – still operational in Bolton at the time of writing. Chesterfield dwellers watching the national TV news whenever affairs of state concerning Northern Ireland are featured may feel twinges of recognition whenever their 1932 Parliament Buildings (designed by architect Sir Arnold Thornely of Liverpool and often colloquially referred to as 'Stormont') are shown, as Chesterfield's Town Hall bears a striking visual similarity from the exterior.

Like all local councils at the time of writing, Chesterfield Borough Council is under intense pressure to make savings after large funding cuts from central government. In 2017 a programme of works was undertaken in the Town Hall including freeing up a floor of the building so it could be rented out to public sector organisations, involving some modernising and homogenising of the affected areas.

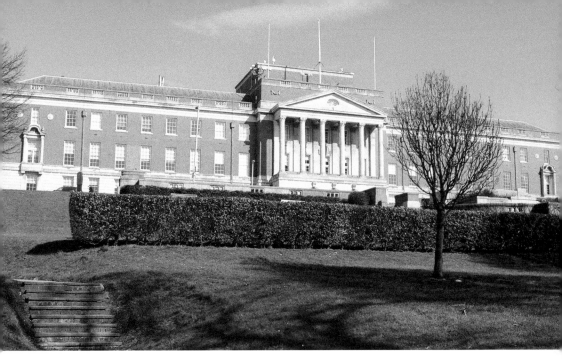

Above: Chesterfield Town Hall.

Below: Where those all-important decisions are made: the Council Chamber, Chesterfield Town Hall.

Committee Room No. 1, Chesterfield Town Hall.

I was told by Chesterfield Borough Council's Conservation Officer Scott Nicholas, who as you would expect has an eye for architectural details, that in his opinion the best room in the building (which I didn't get to see) was the mayoral toilet on the top floor, which had escaped the process of marketisation and regeneration and still contained its original tiling, fixtures and high-level cistern toilet.

42. The Barnett Observatory – 1957–60

As we have previously seen, in the thirteenth century the Abbott of Welbeck built the Eyre Chapel in a strategic location on the high ground of Newbold. A total of 800 years later, Horace Barnett was to select a site opposite the Eyre Chapel for similarly tactical reasons: to build the observatory that bears his name and forms the headquarters of Chesterfield Astronomical Society, on a hilltop location as close to the stars it was his great passion to observe as was geographically possible.

In the late 1950s the surrounding housing estates were yet to be built, and this area was still largely open farmland. Barnett was a man with a vision, namely that Chesterfield deserved its own observatory. After acquiring land at Newbold, Barnett eked small voluntary weekly financial contributions of half a crown out of his

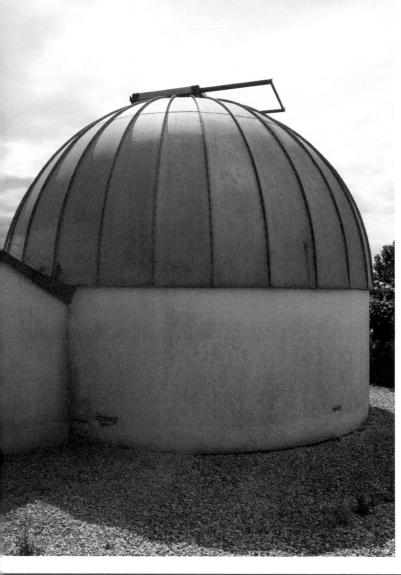

Left: The Barnett
Observatory, Newbold.

Below: The vision:
an architectural
model of the planned
facility. (Reproduced
by kind permission
of Chesterfield
Astronomical Society)

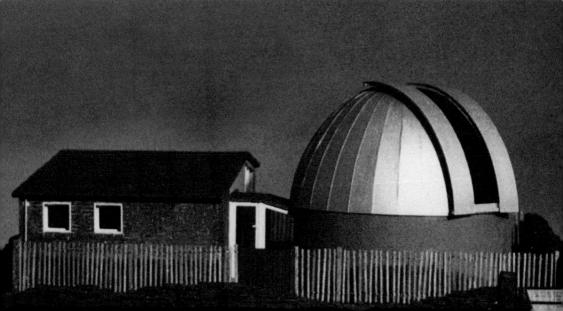

workmates at the Chesterfield Tube Co. to go towards the facilities, and conducted much of the building work himself, recruiting a small team of fellow dedicatees, often working into the night illuminated by candlelight. Such was the enthusiasm of the group and the niche and unexpected nature of the self-propelled project, that the team earned the affectionate nickname of 'the Newbold Nutters' among the townsfolk. The council were supportive of their efforts, contributing a supply of bricks taken from old buildings that they were under a programme of demolishing at the time, and the Chesterfield Tube Co. supported their obsessive employee in allowing use of their workshops for free for the necessary cutting and welding work. The building's exterior was finished with random stonework that came from a recently demolished nearby farm, in an attempt to blend in with the Eyre Chapel.

After three years of steadfast work the completed facility was officially opened in 1960 by the then astronomer royal, Dr Richard van der Riet Woolley. TV astronomer Patrick Moore called it 'probably the finest amateur set-up in the country'. The Chesterfield Astronomical Society are far from possessive when it comes to their observatory, generously throwing open their doors every Friday evening to anyone who cares to come along and join them in a bit of stargazing.

The Newbold Nutters in action: building the observatory with the frame of the telescope cemented in place. (Reproduced by kind permission of Chesterfield Astronomical Society)

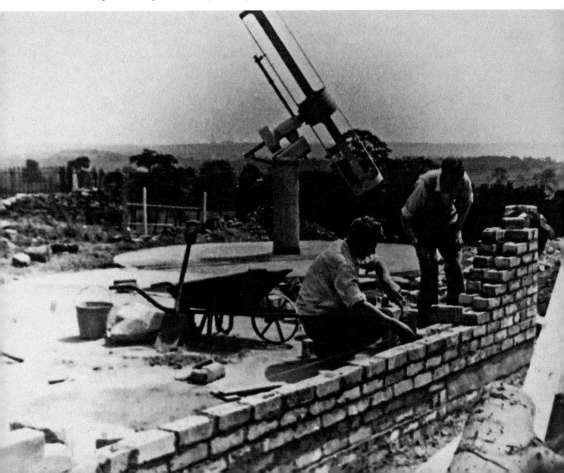

43. Chesterfield Delivery Office – 1960–63

While nowhere near as bold as J. S. Allen's Courthouse, which stands opposite it (see following entry), Royal Mail's Chesterfield Delivery Office is very much of the same era, with all the signs pointing to a 1960s construction: flat roof, random stone, mosaic tiles and large windows. You may think this functional building rather a pedestrian choice, but I am including it here as the sole survivor of a development of buildings constructed in the 1960s when the Post Office's Accounts General Department (referred to locally as the 'AGD') relocated to Chesterfield. This decision was taken after the government concluded that following the heavy bombing of London during the Second World War, having too many administrative departments concentrated in the capital left everyday operations affecting the whole country vulnerable in the event of any future attacks.

A modern office block, Chetwynd House, was built at West Bars next to where the delivery office still stands to house the staff of the AGD, the development being crowned off by the Barbara Hepworth Sculpture 'Curved Reclining Form (Rosewall)', purchased for the new site by Ministry of Public Building and Works.

Chesterfield Delivery Office.

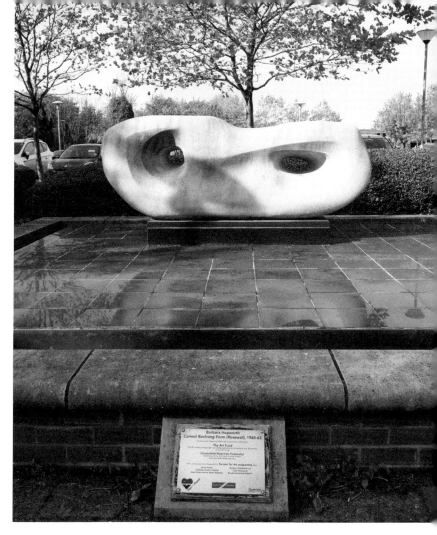

Barbara
Hepworth's
'Curved Reclining
Form (Rosewall)'.

Rosewall was loaned to the Yorkshire Sculpture Park in 2003 for a temporary exhibition. It subsequently emerged that after this relocation Royal Mail controversially planned to sell the sculpture. The Art Fund, Chesterfield Waterside Partnership, and Chesterfield Borough Council's Percent for Art scheme thankfully managed to find enough money down the back of their collective sofa to secure the return of Rosewall to its rightful home in Chesterfield in 2009. Facing it is another modern art sculpture: *Poise* by Angela Connor (2002), which rotates in the wind.

By the time of Rosewall's return, however, Chetwynd House was no more. The building had a very brief shelf life, having to be demolished in 1999 owing to structural problems and being replaced by blander premises in boxy red brick and cheap-looking cladding, the new development aesthetically not living up to its new name of 'Future Walk' by comparison to the previous incarnation. With the Courthouse, original post office development and the presence of 'Rosewall' concentrated in such close proximity, West Bars in its heyday must surely have been the most futuristic corner of Chesterfield!

I'm also very taken with the now-defunct self-service machine built into the wall of the building, with its stopped clock and mysterious sign announcing that due to unspecified 'health and safety concerns' the postboxes will be closed from Friday 28 July 2006 onwards and another sign helpfully advising that stamps are available at 55,000 alternative outlets nationwide, with its implication of consumer choice meaning that you could in practice just nip to Lowestoft or Berwick-Upon-Tweed to get some instead.

44. Chesterfield Courthouse – 1963–65

While public outcry dictated that the radical plan for the transformation of Chesterfield town centre drawn up by Northumbria-based architect Joseph Stanley Allen (1898–1977) remained firmly on the drawing board, Professor Allen did get a chance to give Chesterfield a diminished taste of the modern in the form of his futuristic magistrates court building designed in association with Roy Keenleyside. It is set into the hillside of Shentall Gardens just below the 1930s Town Hall, and seeing the two located side by side illustrates how radically aesthetics in British architecture had changed in the mere twenty-five years between the completion of the Town Hall and the beginning of the Courthouse.

A vision of the future, left to decay: J. S. Allen and Roy Keenlyside's Courthouse building.

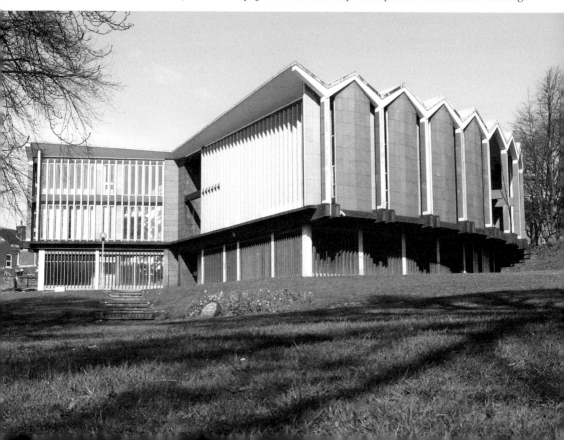

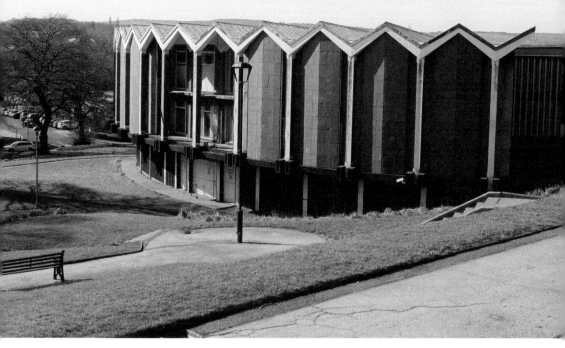

J. S. Allen and Roy Keenlyside's Courthouse building.

A multitude of materials are used in the construction of the building, including reinforced concrete, much glass, natural slate wall cladding and a copper roof. Internally there is a marble staircase and wooden cladded walls. In spite of its futuristic nature, Allen chose to incorporate a curiously whimsical aspect into his design: when viewed from above, the building is shaped to resemble an open law textbook.

Court proceedings were relocated in the late 1990s and the building, also known under the name Knightsbridge Court, was briefly used as offices before being vacated completely in the early years of the twenty-first century. Since then this unique building has remained empty and has sadly been allowed to descend into a sorry state. Somewhat ironically given its original purpose, as has been well documented in the local press, while vacant the building has become the location for a mixed bag of illegal activity including vandalism, anti-social behaviour, graffiti, squatting and drug taking.

Sheffield and Solihull-based practice Thread Architects drew up plans that reimagined the iconic building as a cultural and arts centre for Chesterfield under the name of Knightsbridge Court, but this scheme did not get off the ground. In June 2018 the *Derbyshire Times* reported that the council had granted permission for the Grade II listed Courthouse to be converted into thirty-two apartments, but at the time of writing a year later there seems to have been little progress.

Given the building's short shelf-life and subsequent condition it has been allowed to get into, it seems hard to escape the conclusion that Chesterfield just wasn't ready for modernism...

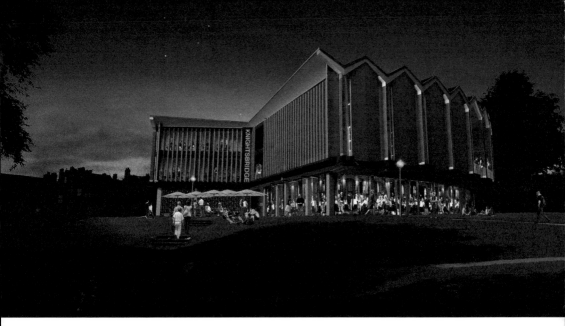

A future vision for the Courthouse as an arts centre as drawn up by Thread Architects, which was not to be. (Reproduced by kind permission of Thread Architects)

45. Loundsley Green Community Centre (former Anglican Church of the Ascension) – 1964

The relocating of the administrative departments of the GPO to Chesterfield meant that large numbers of workers had to up sticks from their previous homes in London, Kent, and Harrogate. A booklet, *Moving To Chesterfield?*, was issued to prepare the staff and their families for life in Derbyshire and, of course, they all needed somewhere to live. A new housing estate was constructed at Loundsley Green on land that had previously been known as the 'Donkey Racecourse' (for discussion on how the name came to be, see p. 68–69 of *Secret Chesterfield*).

This was a large-scale infrastructure project involving the construction of new roads, sewers, schools, shops and two churches (given the steep decline in congregation numbers in the intervening years, it is interesting to speculate whether such a facility would be deemed a necessity if a similar development was being planned today).

The building that is now the Community Centre began its life when the estate was first planned out as the Anglican Church of the Ascension, opening for worship in September 1964, but in the twenty-first century the Anglicans and Methodists joined forces in a local ecumenical partnership to become Loundsley Green Church, based at the former Methodist Church on Pennine Way. The last service in the Church of the Ascension took place in 2010. In its previous incarnation the Community Centre was also used by various groups and activities, so the Loundsley Green Community Trust negotiated continued use

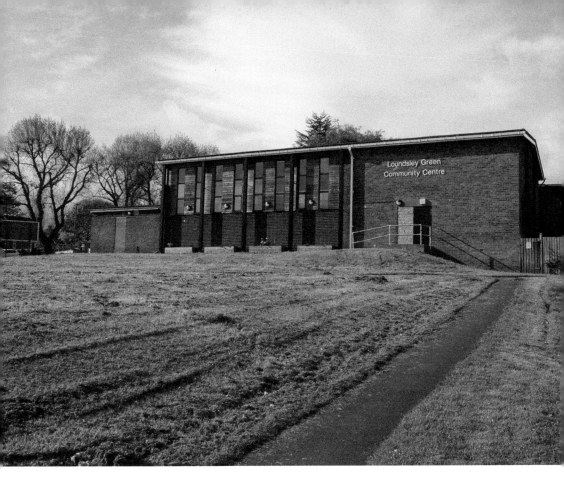

A community hub: Anglican Church of the Ascension reborn as the Community Centre.

of the building for a peppercorn rent rather than see the building lie empty and unused. The Community Centre (opened as such in June 2011) is certainly well-used today, playing host to a wide range of events and services for locals, including baby sensory classes, a ladies' choir, badminton, Scouts, Cubs and Brownies, yoga, dog training classes, a cookery class, and antiques auctions.

46. Brimington Methodist Church – 1967

Perhaps surprisingly, many of the Chesterfield area's most bold and innovative buildings dating from the second half of the twentieth century are churches. There is the 1960s extension to the Norman fabric of Wingerworth Church; the 1970s Quakers Friends Meeting house on Ashgate Road, built to replace previous premises on Saltergate demolished in the 1960s; the former Methodist church built at Loundsley Green to service the new population of displaced GPO admin workers, captured stunningly in black and white shortly after opening in photographs on the RIBA website but since given a more conservative makeover with the unsympathetic addition of sloping tiled roof; and – still to come – the

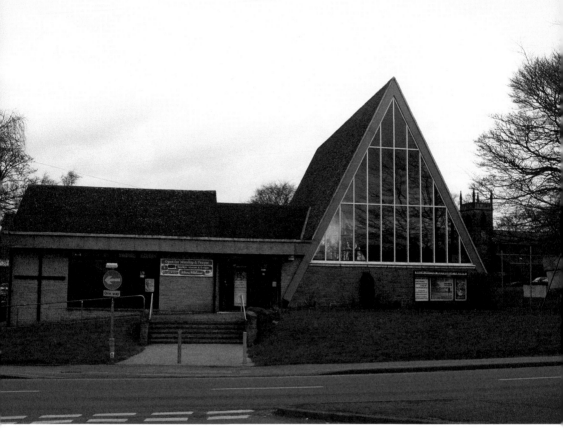

The space-age Brimington Methodist Church.

bizarre 1980s fibreglass bunker that is Temple Normanton's St James the Apostle. And then we have Brimington Methodist Church, designed by Chesterfield-based architects William K. Gill and Geoffrey W. Sellars and opened on 15 April 1967, which by comparison with St Michaels & All Angels Church of 1846 (and its 1796 tower) located just behind it, looks like it has landed from outer space.

By the nineteenth century, Brimington had become somewhat of a stronghold of Methodism, with three separate Methodist places of worship – the Mount Zion, Bethel and Trinity churches – having been built. In the mid-1960s these entities were amalgamated to form the Brimington Methodist Church, moving to their bold new premises on Hall Road on a site adjoining the former Zion chapel. The new building cost £20,500 and has space for 200 worshippers, with an attached schoolroom accommodating 100. After the stone-laying ceremony architect Geoffrey Sellors stated, 'We have seen so many churches, which could frankly have been anything from a schoolroom to a library. What we have tried to do here is create a building which is symbolic of the activity which goes on in it. We have tried to interpret the Gothic style in a modern idiom.' For a week after the formal opening ceremony the building was open every evening from 7–9 p.m. as a local newspaper noted, 'as it is expected that many will want to see one of the most striking new buildings in the area which has such a strong Methodist tradition'.

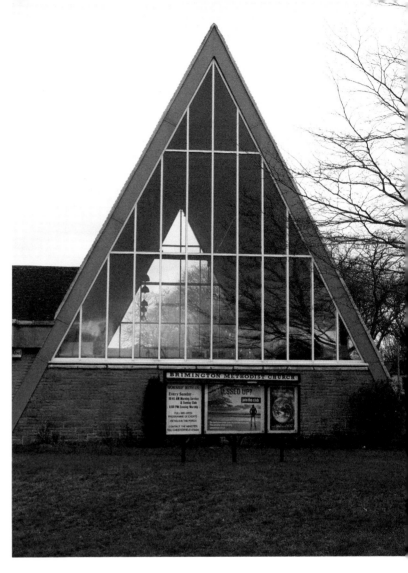

The church's distinctive 28-foot-high triangular window.

After half a century of wear and tear, the distinctive 28-foot-high triangular window had to be replaced by local specialist engineers CMC Aluminium Systems of Dronfield in 2014, and a special blessing ceremony for the new window was held in December of that year, attended by the local MP, Toby Perkins.

47. Places Gym (formerly The Aquarius nightclub), Whittington Moor – 1972

The 1960s saw rapid and seismic developments in British social and cultural life, with a high percentage of people suddenly finding they now had more disposable income. Whether young or old, people's perceptions of how they would spend their leisure time transcended previous generation's expectations. The famous British stiff upper lip quickly became flaccid, hair became longer (in men's case) and higher (women's), and trouser legs ballooned to alarming circumferences.

By 1968 when the American hippy rock musical *Hair* transferred to the Shaftsbury Theatre in London's West End, the performers were appearing on stage full-frontally nude singing about the dawning of the Age of Aquarius.

This zeitgeist even reached as far as Chesterfield the following decade, whose very own dawning of the age of Aquarius took place in 1972 with the opening of the legendary nightclub of the same name – a little piece of Vegas transposed to Whittington Moor. In adverts in the local press it pegged itself as a 'continental nite spot' with a 'Spanish & Zodiac Lounge'.

A succession of stars from the world of light entertainment rolled into town to play the club, including Alvin Stardust, Ken Dodd, Bobby Vee, Marti Caine, Sacha Distel, Les Dennis, Cannon & Ball, Dave Berry, Bob Monkhouse, Del Shannon and (yikes!) Bernard Manning.

Unless you need to get fit, then I wouldn't really recommend bothering with the trip to Whittington Moor to see the former fun palace in the flesh, which now has little architectural merit, the conversion from nightclub to gymnasium having erased all sense of character the building once had, as if Whittington Moor is now a little embarrassed by its glamorous past. The end result resembles a large grey shoe box with holes cut in the sides for windows, and the sign outside with the Zodiac water carrier emptying the letters 'AQUARIUS' vertically out of his pot has also long since vanished.

Goodbye Cannon & Ball, hello rowing machines: the former fun palace The Aquarius reborn as Places Gym.

48. Chesterfield Library – 1985

A 'modest' subscription library opened in Chesterfield as far back as 1791, with the town's first public library opening in 1880 in the Stephenson Memorial Hall (QV). Architecturally there is nothing especially mind-blowing about the current library, which opened in 1985 and is one of the top twenty most-visited public libraries in the UK (although it does make clever use of the topography of its split-level site), but given that the place was a haven for me growing up (and remains so as an adult), I had to include it in my selection. Leaving behind the radical designs and building materials of the 1960s and '70s, the more conservative mindset of the 1980s is evident in the heavy use of red brick in the construction.

The top floor of the library offers a rare glimpse of the historic bowling green opposite, tucked behind a high wall on New Beetwell Street and invisible at street level, which is said to date back to 1294 and therefore the basis of belief that Chesterfield Bowling Club is the oldest bowling club in the world – and a trip to the library is your only opportunity to see the green if you are female, as in 2017 the club made national headlines for their 'traditionalist' stance in continuing to deny female members.

The haven that is Chesterfield Library.

Main entrance to the library, next to the Pavements Shopping Centre.

49. Parish Church of St James the Apostle, Temple Normanton – 1986

If ever there were a competition held for Britain's Strangest Church (is that such a far-fetched idea? There is a televised *Shed of the Year* contest, after all), then Temple Normanton's Parish Church of St James the Apostle, looking more like some sort of post-apocalyptic refuge bunker in a dystopian Stanley Kubrick science-fiction film than a place of worship, would surely be a frontrunner.

The extremely unusual rounded design by M. A. P. Wright constructed of fibreglass was in response to the prevailing geological and climatic conditions of Temple Normanton, which suffers from both mining subsidence (the huge Bond's Main Colliery, operational between 1896 and 1949, was located nearby, as was Grassmoor Colliery) and being buffeted by high winds on its hilltop location. It was consecrated by the Bishop of Derby on 12 October 1986. It is at least the fourth, possibly the fifth church in the village, having replaced a (supposedly temporary) wooden church built in 1923, which itself replaced a short-lived stone church of 1883. This was a replacement for a small chapel known to have been in existence in 1623, and there may have been an earlier chapel in addition – Temple

Where science fiction meets religion: Temple Normanton's Parish Church of St James the Apostle (Mark IV, or possibly V).

Normanton gets its name from the activities of the mysterious religious crusaders the Knights Templar, who held land here in the late Middle Ages.

I was shown around the tiny church by churchwardens Barbara Marshall and Stephen Wright. Barbara remembered the conditions in the church's wooden predecessor, which must have added a dramatic touch of fire and brimstone to the services there. In high winds the lamps suspended from the ceiling used to sway violently in the breeze and the wooden walls used to shake. The far wall of the church was spanned by the pipe organ and at one point towards the end of the building's life the wall would have collapsed in, only the organ held it together. The instrument was also remembered fondly by Stephen who recalled 'the organ used to play by itself' in the high winds. Once halfway through a service there was an almighty crash from the altar rail falling down, but the stoical congregation of St James simply propped it back up and carried on with proceedings.

The 1986 church was itself recently closed for a period of eighteen months after a Chuckle Brothers-style misadventure when Barbara and Stephen each took a back corner of the harmonium to move it in order to clean behind it and Stephen

Interior of St James the Apostle.

fell through the floor ('I moved my corner *correctly*,' Barbara emphasised when recalling the incident). Services took place for the interim period in a parishioner's house who owned a piano (Barbara: 'We needed that, to keep us going'), and after the floor was patched up the interior needed cleaning all over at a cost of several thousand pounds by specialists who scoured it from top to bottom – with nail varnish remover (Barbara didn't care for the smell, which lingered awhile afterwards). 'We have fun and games up here, don't we?', Barbara remarked to Stephen after all these hair-raising reminiscences.

Being the only public space in the village the church also provides a valuable civic role as a community space; a beetle drive had just taken place prior to my visit, and there was a forthcoming ploughman's lunch. My great-grandfather Oscar Frith who was a miner at Bond's Main and his first wife are buried in the churchyard here. When not in use the building is kept locked; visiting information can be found at https://derbyshirechurches.org/church/temple-normanton-st-james.

50. Electricity Substation, Clay Cross – 2009

Perhaps a slightly left-field choice to finish on, and most certainly a left-wing one!

The 1982 edition of the *Derbyshire Guide* begins its entry on Clay Cross thus: 'Clay Cross has had a very bad press in recent years and it might come as a surprise to someone visiting the town for the first time to see that it is not at all an unpleasant place, the hammer and sickle does not fly from every window and that the air is fresh and bracing.' Dennis Skinner, since 1970 the MP for Bolsover, grew up in Clay Cross as one of nine children and began his political career as a member of the Clay Cross Urban District Council. In the 1970s the town council, which then included Skinner's brother David, refused to implement the Tory government's Housing Finance Act of 1972, which would have increased council house rents.

A post-millennium regeneration scheme removed the colliery spoil heaps and brought chain stores to the town, the scheme being capped off with the commissioning of several public artworks, including this one by Peter Maris on an electricity substation, commemorating the strong labour movement in north-east Derbyshire and their involvement in the rent strikes and miners' strikes of the late twentieth century.

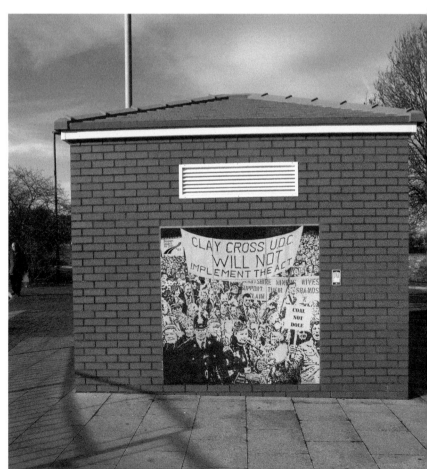

The area's left-wing pedigree immortalised in a public artwork on the side of an electricity substation, Clay Cross.

Bibliography

Aldous, Tony, *New Shopping in Historic Towns: The Chesterfield Story* (London: English Heritage, 1990)

Botham, D. F., *A history of Chesterfield Market Place: Or, An 800 year old Shambles – An Architectural History Celebrating Eight Centuries of Change Since the First Royal Charter* (Chesterfield: D. F. Botham, 2004)

Bradley, Richard, *Secret Chesterfield* (Stroud: Amberley Publishing, 2018)

Edmunds, W. Hawksley, *The Crooked Spire of Chesterfield: Historical and Other Notes; How it was Saved from Destruction by Fire* (Chesterfield: *Derbyshire Times*, 1963)

Hallam, Anthony J., *The Family-Markham 1823–2003* (Chesterfield: Anthony J. Hallam, 2006)

Hornsey, Brian, *Ninety Years of Cinema in Chesterfield* (Stamford: Fuchsiaprint, 1992)

Howard, W. F., *Stephenson Memorial Hall, Chesterfield* (n.p.: Bemrose, 1880)

Innes-Smith, Robert (ed.), *Derbyshire Guide* (Derby: Derbyshire Countryside Ltd, 1982)

Jenkins, David, *An Historical Scrapbook: A Collection of Essays About the Chesterfield Area* (Chesterfield: Bannister Publications, 2008)

Pendleton, John & Jacques, William, *Modern Chesterfield: Its History, Legends, and Progress* (Chesterfield: *Derbyshire Courier*, 1903)

Porteous, Crichton, *Pill Boxes and Bandages* (Chesterfield: Robinson & Sons Ltd, 1960)

Stone, Richard, *Buildings In Derbyshire: A Guide* (Stroud: Amberley Publishing, 2011)

Thompson, Len, *A History of Tapton House* (Cranleigh: Len Thompson, 2000)

Anon, 'Changing Face of Chesterfield', *Derbyshire Countryside*, Vol. 28, No. 4 (June 1963), p. 43–7

Anon, 'Looking at the Stars', *Derbyshire Countryside*, Vol. 25, No. 5 (August 1960), p. 27

Born, J. N. – 'The Barnett Observatory'

Arnold, Alison, Howard, Robert and Tyers, Cathy, *Research Report Series 59-2016: Brampton Manor Barn, Old Road, Chesterfield, Derbyshire – Tree-ring Analysis of Oak Timbers* (Portsmouth: Historic England, 2016)

Barson, Susie – *Miners' Offices, Saltergate, Chesterfield, Derbyshire: A Report on the Historical and Architectural Interest of a Purpose-Built Union Office Building, and Recommendation for Listing* (n.p.: English Heritage, 1998)

Chesterfield's Black and White Buildings (Chesterfield: Chesterfield & District Local History Society, 2015)

All Saints Wingerworth Visitors Guide

http://www.derbyshireheritage.co.uk

http://www.chesterfieldcivicsociety.org.uk

https://www.chesterfield.gov.uk/planning-and-building-control/conservation-and- heritage/conservation-areas.aspx

http://www.aboutderbyshire.co.uk

https://historicengland.org.uk

https://en.wikipedia.org/wiki/List_of_twisted_spires

https://www.derbyshiretimes.co.uk/news/punters-cry-out-to-save-chesterfield-s-oldest-pub-1-7527051

http://www.thedogkennels.co.uk

http://www.achesterfieldblogger.co.uk/scarsdale-vaults-brewery-etc/4593456772

http://www.holytrinityandchristchurch.org

https://www.chesterfield.co.uk/visiting/shopping/chesterfield-town-centre/chesterfield-market-hall/

http://friendsofspitalcemetery.co.uk/history/

https://raggedschoolchesterfield.wordpress.com/

http://audiotrails.co.uk/claycross/

https://www.architecture.com/image-library/ribapix.html?keywords=loundsley%20green

http://www.chesterfieldcivicsociety.org.uk/wp-content/uploads/2017/02/Local-Plan-Comments.pdf

https://en.wikipedia.org/wiki/New_Bolsover_model_village

https://en.wikipedia.org/wiki/George_H._Widdows

https://web.archive.org/web/20160507012752/http://www.blackandwhitebuildingsofchesterfield.co.uk

https://en.wikipedia.org/wiki/Burton_(retailer)#Architecture

http://www.chesterfield-as.org.uk/

https://modernmooch.com/2017/08/21/chesterfield-magistrates-courts/

Derbyshire Record Office

D3817 – Brimington Methodist Church, Hall Road

D6449 – Chesterfield Civic Society – unlisted accession, September 2005

Acknowledgements

Thanks go to Andy Booker, Lisa Came, Donna Corbin (Philadelphia Museum of Art), Mark Eustace and Chesterfield Astronomical Society, Revd Judy Henderson Smith, Revd David Horsfall, Craig Lynch, Barbara Marshall, Christine Merrick and Chesterfield Historical Society, Scott Nicholas, Francesca Russell, Andy Thomas and Thread Architects, Ian Thomason, Dave Wallace, Stephen Wright, the staff of the Royal Oak and Peacocks Coffee Lounge.

The staff of Chesterfield Library (especially the nice chatty lady at the counter) and Derbyshire Record Office. Becky Cousins, Nick Grant, Nikki Embery, Jenny Stephens and Philip Dean at Amberley Publishing. Mum, Dad, Kate, Oscar and Leo for their endless support and patience, chauffeuring and proofreading during the making of the book.

About the Author

Richard Bradley was born in Sheffield and grew up at Oaker and Two Dales, near Matlock. He now lives in Sheffield with his partner and two sons.

His interest in architecture developed during his first 'proper job' at the University of Sheffield's mid-century modernist Western Bank Library through contact with books in the Architecture and Geography Libraries there. Consequently, joining The Twentieth Century Society, he was mercilessly mocked by colleagues for paying to go on a tour of Sheffield's modernist buildings one weekend, which included the very building he worked in five days a week.

His main research interest is Derbyshire folklore and customs. *Chesterfield in 50 Buildings* is his third book for Amberley after *Secret Chesterfield* (2017) and *Secret Matlock and Matlock Bath* (2018). He has also written for a variety of magazines including *Derbyshire Life*, *Best of British* and *Record Collector* and had photographs published in the *Sunday Times*, *Sheffield Telegraph*, *Discover Britain* magazine and *Prog* magazine.